IMAGES
of America

CENTRAL CONNECTICUT
STATE UNIVERSITY

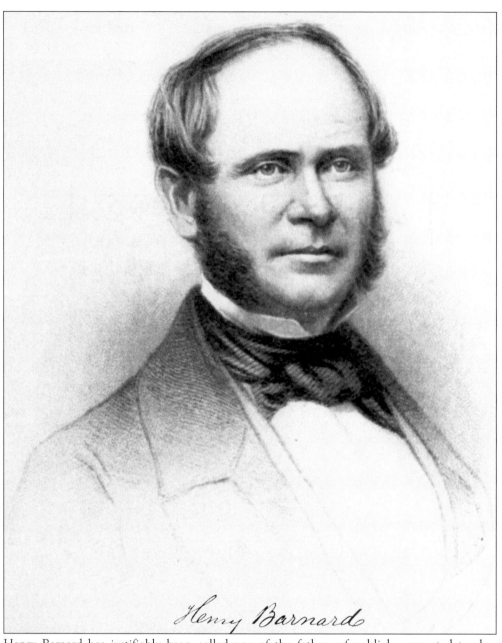

Henry Barnard

Henry Barnard has justifiably been called one of the fathers of publicly supported teacher education in Connecticut. As early as 1838, before any public normal schools had been established in the U.S., he was pushing the issue before the state legislature. Failing in Connecticut at that time, he went to Rhode Island to become Commissioner of Common Schools. In 1849, when Connecticut finally passed legislation establishing a normal school, Barnard returned to Connecticut to become its first principal. He left in 1858 to become chancellor of the University of Wisconsin and later became president of St. Johns College. In 1867 he was appointed first U.S. Commissioner of Higher Education, a position he held until 1871.

IMAGES
of America

CENTRAL
CONNECTICUT
STATE UNIVERSITY

George R. Muirhead

ARCADIA

Published by Arcadia Publishing,
an imprint of Tempus Publishing, Inc.
2 Cumberland Street
Charleston, SC 29401

Printed in Great Britain.

Library of Congress Catalog Card Number: 99-62234

For all general information contact Arcadia Publishing at:
Telephone 843-853-2070
Fax 843-853-0044
E-Mail arcadia@charleston.net

For customer service and orders:
Toll-Free 1-888-313-BOOK

Visit us on the internet at http://www.arcadiaimages.com

Acknowledgments

It is impossible to thank all the people who are responsible for this book. We do not even know who many of them are. There are dozens of nameless photographers, professional and amateur, who made this book possible. There are also a few who can be named—Ed Schullery, Roy Temple, and Peter Kilduff.

So far as the book itself is concerned, there are some who have been indispensable:

Lani Johnson, who had done this before and whose idea it was;
Frank Gagliardi and his staff, who did the absolutely essential archival research;
Leroy Temple, the technician who turned dross into something resembling gold;
Susan Malley, my administrative assistant, who put this together with both competence and
 good humor;
the CCSU Alumni Association, which gave support;
and my wife, Ann, who provided editorial assistance.

CONTENTS

INTRODUCTION

The Normal School, 1849–1933.
Teachers College of Connecticut (TCC), 1933–1959.
Central Connecticut State College (CCSC), 1959–1983.
Central Connecticut State University (CCSU), 1983–present.

From an institutional point of view, these are the four phases through which the institution has developed throughout the last 150 years. They provide the outline of a story of growth and change. The Normal School was a diploma-granting, teacher-training institution with courses of two and three years. TCC remained a teacher-training college, but it had degree-granting authority at the B.S. and later M.S. levels. CCSC represented a breakthrough into non-teaching programs—B.A. and B.S.—in the liberal arts and non-teaching professions such as business. CCSU, with its university status, suggests an entity with greater commitment to research and formal scholarship and a vision, which includes the consideration of a doctorate, at least in education. The living history of the institution is embedded in the periods themselves. However, the development follows no simple Hegelian dialectic process.

One of the early American exponents of the normal school concept was Henry Barnard. In 1838, at the age of 27, he became chairman of the Committee on Education in the Connecticut General Assembly. Yet even that position was not powerful enough to secure the passage of normal school legislation. So the first five public normal schools were established elsewhere, and a discouraged Barnard went to Rhode Island. In 1849, however, the Connecticut Legislature passed the legislation establishing the Connecticut Normal School, which was to be sited in the community that bid highest for it. Thanks largely to the efforts of Seth North, New Britain was the high bidder—$16,250, not a bad figure when one considers that the State had guaranteed only $10,000 over a four-year period to operate the school. That and the promise of a building brought the school to New Britain. And Henry Barnard came back from Rhode Island to be the first principal when the doors were opened to students in May 1850.

The Connecticut Normal School, as it was officially called then, remained in the downtown New Britain building until the 1880s; it shared the building with New Britain High School and a demonstration elementary school until the 1880s. There were signs of stability and success in the early years: the State's annual appropriation was raised in 1853 to $4,000, and in 1863 the school was evaluated favorably by a committee of the legislature. On the other hand, there were symptoms of instability; for a term in 1853 the associate principal and the principal of the high school downstairs did not speak to each other. Both left. Barnard himself left in 1855, and there would be three principals in the next dozen years—John Philbrick, David Camp, and Col.

Homer Sprague. This period included the Civil War, which affected male enrollments. Worse, however, was the refusal of the general assembly to fund the school for two years—1867–69. This derived from the first case of conflict between public and private interests in higher education. The interests of private teachers' seminaries prevailed at a moment when the legislature was looking for ways to save money during the postwar depression.

With the Normal School closed, Colonel Sprague ran for the state house of representatives and became chairman of the Education Committee. From that position he secured legislation to reopen the Normal School though he did not return as principal.

The remainder of the century was relatively calm and successful. From 1869–94 there were only two principals, Isaac Carleton and Clarence Carroll. And the principal who came in 1894, Marcus White, remained until 1929. Enrollments grew for a time as the population grew, and the demand for properly trained teachers became more common. Indeed, this demand for teachers would indirectly have an effect on the enrollments at the New Britain school. Between 1889 and 1905, normal schools were established by the legislature in Willimantic, New Haven, and Danbury. (Within a dozen years of its founding, New Haven had a larger student body than New Britain.)

A more obvious indicator of success was acquisition of new and better facilities. Early in Carroll's administration the legislature was persuaded to allocate $75,000, and New Britain supplemented $25,000 of its own to build a new, larger Normal School building, and by the mid-1880s it was completed on Walnut Hill. It would serve as the school building until the 1920s, but from early in the 20th century it was being outgrown.

Marcus White, who had become the principal in 1894, favored the raising of standards of admission for Normal School students. The result was a slowing of growth in the years leading up to World War I, but by then the 30-year-old building was inadequate. White succeeded in 1919 in getting authorization to purchase 25 acres in northeast New Britain and to hold an architectural competition; this all cost $60,000. Two years later he received $750,000 to build a power plant and classroom building on the Belvidere site. Strikes and delivery problems notwithstanding, the new building was occupied in 1926. Not satisfied, White pursued a dormitory for women (there were no men at that time), which was funded at $350,000 in 1927 and occupied in 1929—just in time for the Great Depression.

With White retiring in 1929 in ill health, H.D. Welte was brought from the Midwest as principal; he would soon be the first president. In 1933 the legislature, in the depths of the Depression, acted remarkably; it turned New Britain's Normal School into the Teachers College of Connecticut with baccalaureate degree-granting powers and, by implication, intended to close the other three normal schools. This was, on the one hand, a concession to improving standards in teacher-training institutions around the country and, on the other, an attempt at cost cutting. To the extent that the specific bill to close the other three failed, the strategy failed; however, as a result of the bill, TCC had been created with primary responsibility for training secondary school teachers in academic disciplines at the baccalaureate level.

The 1933 legislation changed the complexion of the institution. Men returned, at least till World War II took them away again. New academic disciplines with new, credentialed faculty were brought in—English literature, the social sciences, the natural sciences, higher mathematics, etc. These would be the academic foundations on which the CCSC curricula would eventually be based. These were also the subjects that brought more and better students. After the low enrollments of the 1930s and the war years, enrollments were up to 1,000 by 1950 and to 2,000 by 1960. Following these changes in function and size, the period from 1946 to 1959 was a particularly dynamic one. This time was marked by a new gymnasium, two new classroom buildings, a new library, a new men's dormitory, and expansion across Wells Street for a football field. One serious cloud did appear on the horizon, however.

In the 1953 session of the general assembly the University of Connecticut (UConn) introduced a bill (HB 1013) that would have transferred all preparation of secondary school

teachers to the University of Connecticut. This was a frontal assault on the teachers colleges, especially TCC, which did most of the training in academic disciplines. Dr. Welte assembled a small task force led by Harold Bingham, a history professor charged with defeating the bill. Letters to editors and student action helped, but it was primarily Bingham's lobbying efforts that resulted in the defeat of the bill. The consequences were twofold: secondary-teacher education was saved for the teachers colleges, and Dr. Welte discovered how much political clout he had through the hundreds of teachers and administrators who were alumni. It was this new power base that Bingham used to achieve legislative approval of the capital projects of the late TCC period and early in the CCSC era. His success was remarkable.

Six years after the great threat of 1953 the teachers colleges became state colleges. This was a recognition of a national trend in which the strong academic base of teacher education could readily graft onto it broad baccalaureate- and master-level programs without the pedagogical focus. Thus arrived an array of non-teaching programs in business and technology as well as the arts and sciences. Between 1960 and 1973 the enrollment quadrupled—from 2,000 to 8,000. The faculty was enlarged accordingly, and Bingham's master plan for facilities construction continued to be implemented until the early 1970s.

There were other changes besides size and scale. Bingham helped the new state colleges separate from the State Department of Education; he then became the executive secretary of a separate Board of Trustees for State Colleges. There he pressed for a strong "system" for state college governance, a direction resisted by Dr. Welte and the other strong presidents. Bingham lost and was gone. Then, in 1968, Dr. Welte retired, and the next 18 years would be under the leadership of Dr. F. Don James, who came just as the pressures of the 1960s erupted.

Dr. James's early years were challenging. Not only was CCSC approaching an all-time high in enrollments, it was feeling the effects of the activist 1960s. There were student protests, both major and minor, over Vietnam, racial politics, food, and even registration procedures (students threatened to burn their library cards). Administratively, CCSC was changing as well. Schools—Arts and Sciences, Education and Professional Studies, Graduate—were created, and the undergraduate ones were structured along divisional lines. Two of these divisions—Business and Technology—were soon to become schools themselves. In structure, size, and programs, CCSC and her fellow state colleges were moving along a national trend toward yet another level, that of University. U-Day came on a beautiful spring day in 1983.

Dr. James retired three years later, to be followed by Dr. John W. Shumaker. His tenure was recognizable by increased entrepreneurial efforts through the extension of CCSU's expertise into both the community and the world. Notable was the successful multi-million-dollar USAID project on management training and economic education in Poland. He also placed new emphasis on faculty research and publication as a measure of university status. By 20th-century CCSU standards, Dr. Shumaker's tenure was short; he left in 1995. Succeeding him was Dr. Merle Harris, who was borrowed from Charter Oak State College for a year.

Since 1996 the president has been Dr. Richard L. Judd, a TCC alumnus and a member of the administrative staff since 1964. He has reaffirmed CCSU's historic commitment to excellence in teaching yet has shown his support for scholarship and for CCSU's role in the regional and world economies. He is also committed to a new look at CCSU itself.

For roughly a quarter of a century, the face of CCSU's campus has changed little. In this sesquicentennial year we see evidence of dramatic change. The administration building (Davidson Hall) and Marcus White are getting face lifts. A new "skirt" exists around Copernicus. A major classroom building is under construction. The student center is to be totally renovated. A new heating system is about to come, and there are plans for Willard and DiLoreto.

The most complete history of the early years is to be found in Herbert E. Fowler's *A Century of Teacher Education in Connecticut*, New Britain, published by Teachers College of Connecticut, 1949. Thus, as we look beyond the sesquicentennial and toward the next millennium, we see a Central Connecticut State University that is alive and well.

One

THE NORMAL SCHOOL

Altogether, the period of the Normal School spans more than half the lifetime of the institution. Of the 150 years being celebrated in this book, the first 83 are the Normal School years if one combines the periods of the Connecticut and the New Britain Normal Schools. For various practical reasons, it is sensible to do just that.

When additional normal schools were added in Willimantic, New Haven, and finally Danbury, there was no interruption in the history of the New Britain institution. Indeed, the general assembly approved the appropriation of funds for the new Walnut Hill building just six years before it authorized the second normal school in the state. There was no substantial change in the Normal School's focus just because there were to be additional venues for teacher training.

The other reason for a single chapter on the Normal School period is a practical one. Photographic imaging was a new thing in the 1850s, and the resources available from the 19th century are slim. They are either outdoor photographs in natural light or posed studio pictures. The amount of surviving 19th-century photos is surprising. The library, and with it the archives, was moved to at least six different locations between 1850 and 1972.

So the longest period left the fewest images, but those we do have provide a record of growth and development.

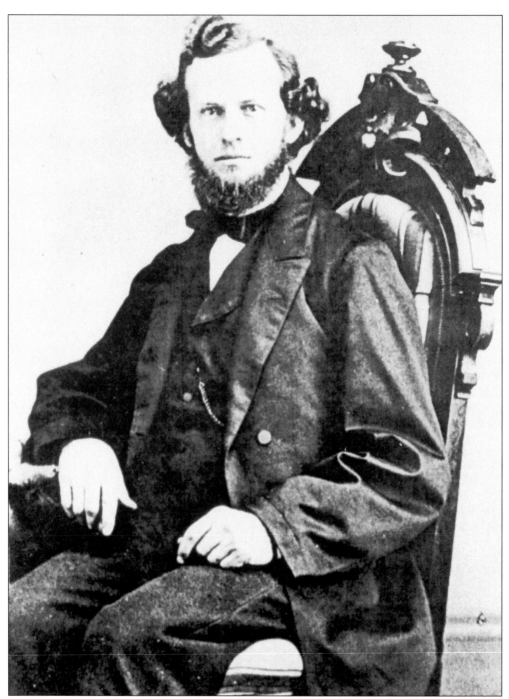

Franklin C. Brownell was one of the students present at the opening of the Normal School in 1850. He was already an experienced teacher and dropped out in order to teach in Wallingford the following winter (for $1 per day plus room and board). Nevertheless, he was graduated in the autumn of 1851 and continued to teach for the next five years. Subsequently, he became a ". . . dealer of school furniture and apparatus" in New York City and New Jersey. He died of consumption in 1871.

State of Connecticut

NORMAL SCHOOL.

New Britain, Conn., October 1st 1851.

This is to Certify, That *Franklin Clinton Brownell,*

has pursued and completed in a satisfactory manner, the course of study of the

STATE NORMAL SCHOOL,

and is deemed competent by the Faculty, to enter upon the duties of a teacher in the

COMMON SCHOOLS OF CONNECTICUT.

D. N. Camp. *J. D. P. Stone* *Associate Principal.*

In accordance with the above certificate, the Trustees have granted this

DIPLOMA.

Henry Barnard, *Secretary.* *Francis Gillette* *President.*

Brownell had been associated with the Normal School less than 18 months (including the winter term he spent teaching) when he received his diploma—diploma number two issued by the school, in fact—in October 1851. It depicts the Normal School building and is signed not only by Henry Barnard but also by David Camp, who would be a future principal.

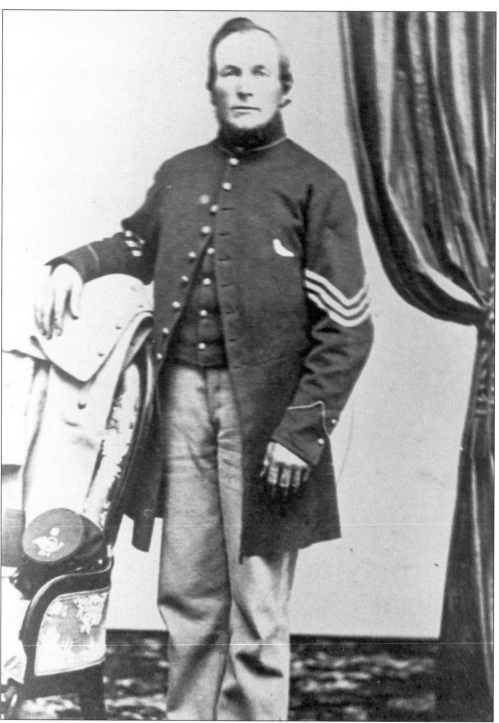

Edwin Keyes was another early graduate. He entered in the autumn of 1851 and received his diploma 38 weeks later. He had previously taught at a salary of $21 per month. After graduating he was soon earning $50 per month. He entered the Union Army in the Civil War, reaching the rank of sergeant. Wounded in May of 1863, he died the following month in Baton Rouge.

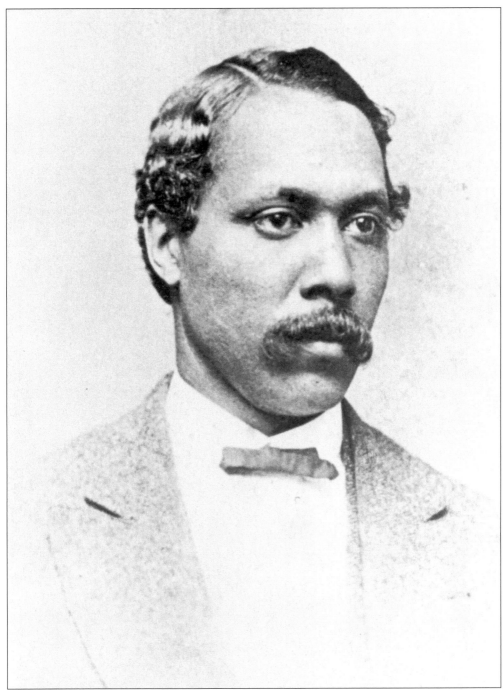

The first African American to be graduated from the Normal School was Ebeneezer Don Carlos Bassett, a native of Litchfield. He completed his program with honors and subsequently served as principal of Whitney Street School in New Haven while he continued his education at Yale. From 1857–69 he was principal of The Institute for Colored Youth in Philadelphia. In 1869 President Grant appointed him as the first U.S. minister to Haiti and the Dominican Republic, thus making him the country's first African-American diplomat.

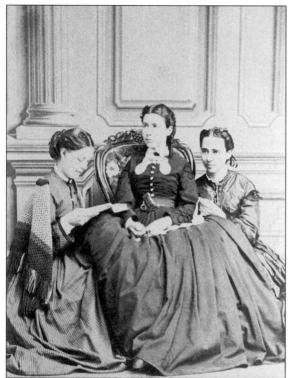

Mary Baldwin (center) was photographed on St. Patrick's Day, 1866, in the home of Professor Camp. A native of Illinois, Mary entered the Normal School at the age of 16. She was graduated from the program at 19 in 1867; her total expenses were $650. She did not get a job until 1870 and then taught briefly in Glastonbury. The school lost track of her by 1877. By contrast, Harriet Marshall (right) started teaching without qualifications at 16, entered the Normal School at 18 and was graduated after 38 weeks. After teaching in Danbury and New York City, she returned to the Normal School at the age of 29 as a member of the faculty, qualified in Latin and French. The woman on the left could not be identified.

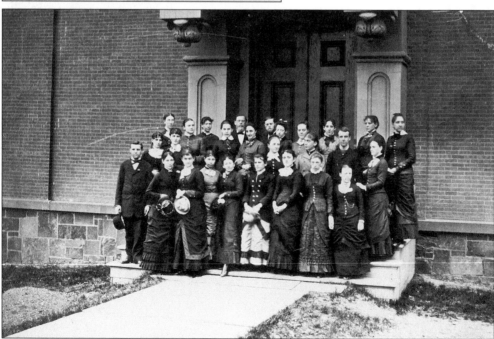

The Class of 1881 was photographed on the steps of the first Normal School building. It would be among the last to do so. The "new" building was already being constructed on Walnut Hill. It is worth noting that men were still in attendance, albeit as a minority. There are 23 women and only four men in the "proper" group, well, quite proper: one ankle almost shows.

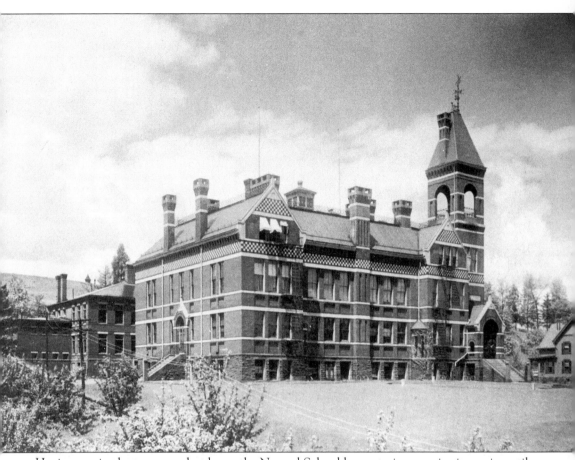

Having survived a two-year shutdown, the Normal School began to increase in size again until it had outgrown the old place on Main Street. In 1880 the general assembly approved an appropriation of $75,000 for a new building, provided New Britain would chip in an additional $25,000. Once again New Britain proved its generosity, and the new Normal School was erected on Walnut Hill. It was occupied in 1883.

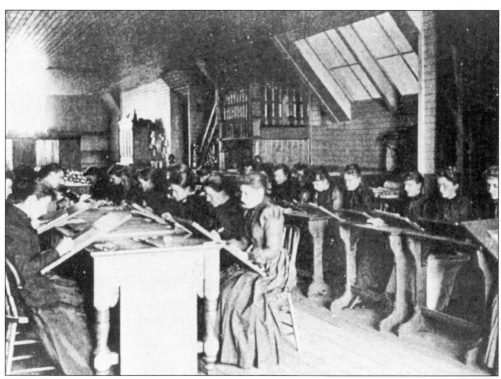

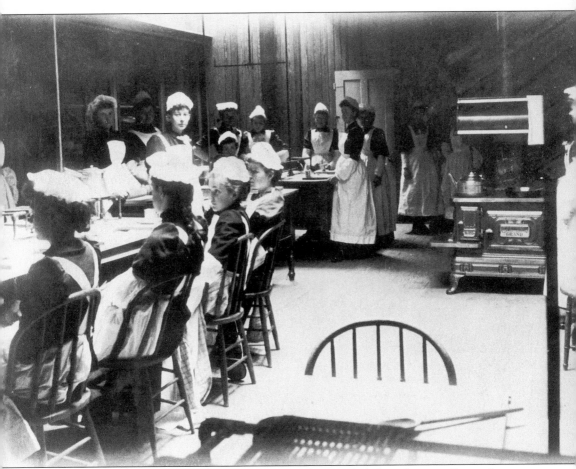

From the beginning, Henry Barnard's curriculum had included reading, spelling, phonics, geography, English grammar and composition, arithmetic, history of the U.S., drawing, vocal music, and declamation. The new building provided space and facilities for an enhanced curriculum. Not only was there a large dedicated space for art (top left), there were practical new courses available. There was instruction in manual training (bottom left) and in home economics (above). But with manual training or not, the student body was by now almost entirely female.

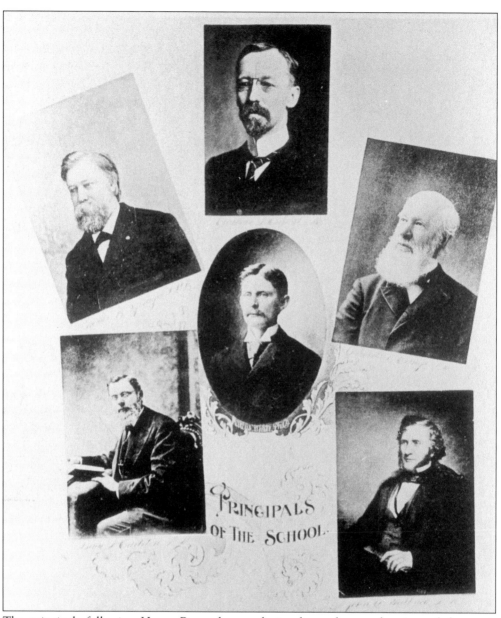

The principals following Henry Barnard were depicted together at the time of the semi-centennial. They are, from left to right, as follows: (bottom row) Isaac Carleton and John Philbrick; (center row) Marcus White; (top row) Col. Homer Sprague, Clarence Carroll, and David Camp. The depiction shows no rational order. Philbrick succeeded Barnard in 1855 for two years. Camp served from 1857 until 1866. Colonel Sprague was the principal for only a year before the legislature closed the school, but he was instrumental as a legislator in the reopening of the school in 1869. Carleton, an underrated principal, brought the school back to life and had achieved the funding for a new building before he retired in 1891. His successor, Carroll, served until 1894, when White was appointed.

African-American students were not common in the Normal School years. Ebeneezer Bassett had been a notable and distinguished exception. The Class of 1896 graduated another—Mary Anderson. Records from that period are not good, but it is known that she had a public school education, played a musical instrument, and was a Methodist. She later married and lived in Indianapolis. It will be noted that the class was quite small. By 1896, normal schools had recently been opened in Willimantic and New Haven. There was finally competition in the public sector.

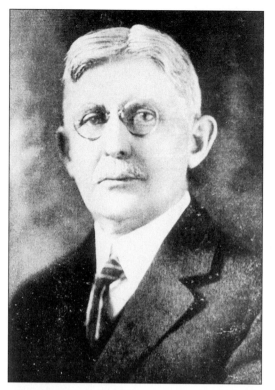

Marcus White, the seventh principal of the Normal School, assumed his office in 1894. The early years of his administration were a time of low enrollments, but the school prospered sufficiently, and by World War I White was campaigning for new, larger quarters. He lived to see the new campus occupied before he retired in ill health in 1929. He died later that year.

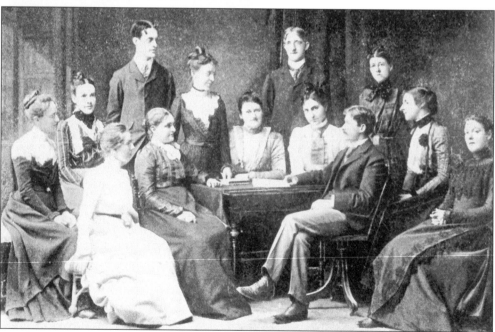

At the time of the semi-centennial in 1899–1900, the faculty had its photograph taken. Seated at the desk is Principal Marcus White surrounded by his 12 faculty members. However small, these few had a good student-faculty ratio: the Class of 1895 had only 18 members, the Class of 1905 had 20 (and this at a two-year school).

This photograph of the class of 1905 provides evidence that the Normal School was not growing in enrollment in the early part of the century. There were only 20 in the class, all women. At this point the newer Normal School in New Haven had achieved a larger student body.

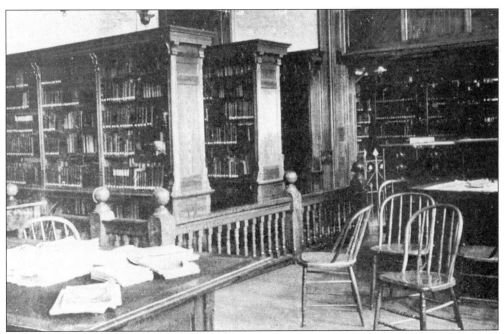

The "new" building was not the brightest and cheeriest of places. It had rather small windows and dark woodwork. The furniture was not too comfortable, either, and the gas lighting was minimal. When this photograph was taken in 1894, the enrollment had fallen below 200. (This may be a specious correlation.)

Basket Ball

The first game of basket ball since the opening of sschool this fall, was played in the gymnasium on Oct. 11, 1905.

The game was between the Seniors and the Juniors and the result was a tie, the score being two - two.

The playing was not up to the Normal standard on either side, but this was due to the fast that the game was played without any prastiss, and some of the girls had never played logethen before.

As the prosceds were for the benefit of the Pioneer the editors and senior class cordially

thank all who witnessed the game.

We hope to be able to play again and assure our patrons that next game will be well worth the admission of two for five.

The following girls composed the two teams:

Juniors. Seniors.

Miss Tooey Center Miss M. Kilfoil.

Miss Kilbourne Forward Miss J. Freney.

Miss Johnson Forward Miss L. Berg.

Miss F. McGuire Guard Miss A. Stark.

Miss Corr Guard Miss J. Drago.

What has to have been one of the earliest reports of a girl's basketball game appeared in the *Pioneer* in 1906. The game had been invented at Springfield College scarcely ten years before, and already the Normal School gymnasium was equipped with baskets. What is interesting is that they were playing by men's rules—five on a side. Later, women's rules would change to teams of six playing in two zones. The report is historically interesting, but it was not much of a game.

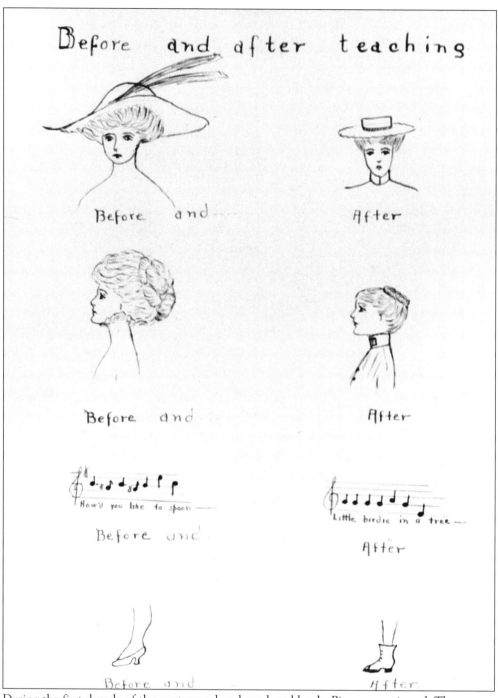

During the first decade of the century, a hand-produced book, *Pioneer*, was issued. There seem to have been editions published quarterly, starting in 1901. A recurring theme is the expectation of conformity and conservative behavior on the part of teachers and intending teachers. Examples having to do with style are reproduced as representative of what passed as Normal School humor.

A further, more general commentary appears in this cartoon. The Normal School has a clearly homogenizing effect on those who enter, and there is an implicit commentary on retention rates as well. The art work here (1909) shows a little more sophistication.

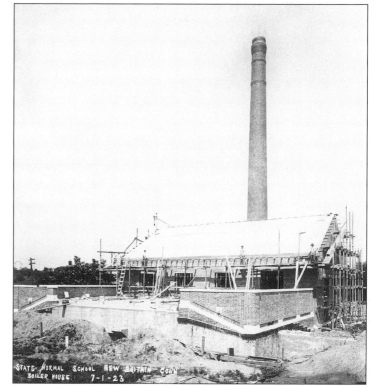

One of the first two buildings necessarily constructed on the new Belvidere site was the powerhouse—identified here as the "boiler house." The photograph is dated "7-1-23." Obviously, the Normal School was not going to open without a steam generating plant. Seventy-five years later it is still the powerhouse.

One of Marcus White's ambitions was to acquire a new, larger campus with a women's dormitory, but it was 1919 before the State could be persuaded even to buy the land—25 acres in the so-called Stanley Quarter for $95,000. A competition was held among architects for the design. The firm of Guilbert and Betelle won the contract for their genteel Georgian design. In 1921, $750,000 was allocated for the main building and the powerhouse, but the work was not completed until 1925 because of strikes and other labor problems.

Principal White's ambitions for a women's dormitory were realized in 1927 when the legislature appropriated $350,000 for a 100-bed facility at a time when it could accommodate a third of the student body. It was built according to the Guilbert and Betelle design and was compatible with the main building and the powerhouse. It was finished in 1929, the year White died, and was named for him.

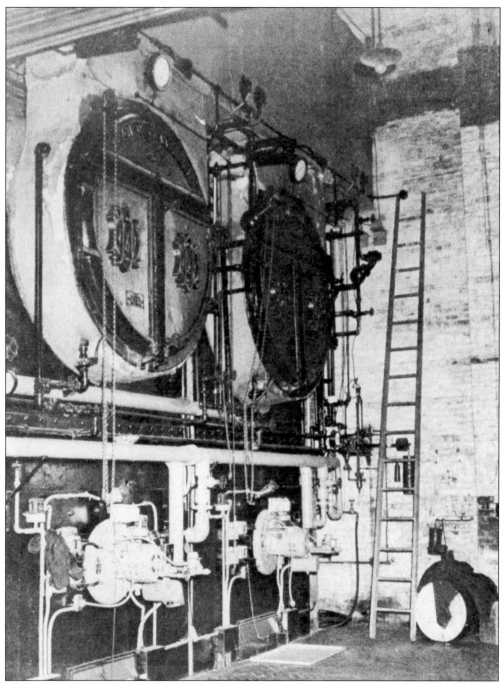

This is a view that most alumni have never seen—the inner workings of the powerhouse. Built as the necessary first phase of the Belvidere project, it held the boilers for the original buildings and is still the main power source for the campus. After 75 years, it is soon to be replaced, but it has served nobly. Everyone knows its smoke stack; few have visited its bowels.

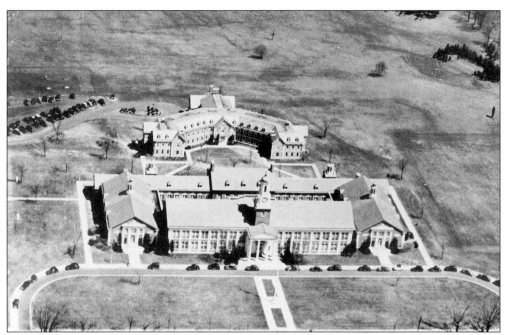

As late as the end of the 1930s there were only three buildings (the powerhouse is not shown) on a rather empty campus. But in the upper-right-hand corner the outdoor amphitheater with its backdrop of conifers and raised "stage" is discernible.

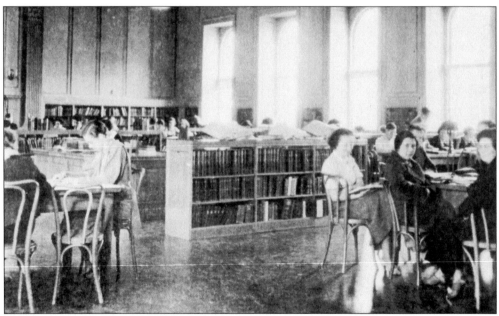

Compared to the library in the Walnut Hill building, the one in the new administration/classroom building was airy and spacious. The chairs were not much more comfortable, however. When the main library was moved to East Hall after World War II, this remained the reserve room. Later, it served as the Office of Admissions and Registrar before being set aside as the gracious Founders Hall.

Marcus White Hall, the first dormitory (women only, of course), was completed in 1929. This picture was taken about 1934 for marketing purposes. There were either no occupants or very neat ones.

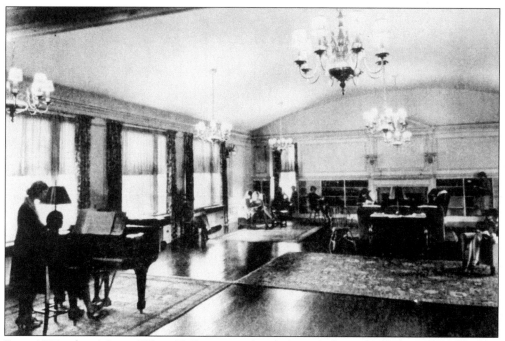

From 1929, when Marcus White Hall was completed, through the entire TCC period, there was one graceful room in the College: the Marcus White Living Room. It was here that genteel social occasions were held. This being a women's dormitory, men's access was strictly limited and controlled. They were denied the use of all but one staircase to the living room on the second floor.

ATHLETICS

When the new campus was occupied in 1925, there would be new practices established that would become traditions. One was a professionally produced annual, the *Dial*, which was more sophisticated in every way than the earlier *Pioneer*. Examples of artwork from 1925 and 1926 show the influence of art nouveau in its later stages. If the treatment of athletics is surprising, remember: this was a single-sex school where sports were largely recreational.

The Normal School remained a single-sex institution through the 1920s. Nevertheless, the students were expected to "dress." Hats, gloves, and hose were normal expectations as befitted intending teachers. Nevertheless, there existed a sense of style—a commitment to the cylindrical figure and the belted hips.

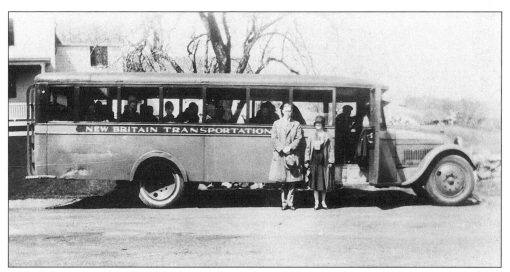

Although the new building had been occupied in 1925, some classes continued to be held in the Walnut Hill building for the next few years. For convenience, a shuttle bus ran from there to the Stanley Street site. (For other commuters, there was the trolley line, which ran to Hartford.)

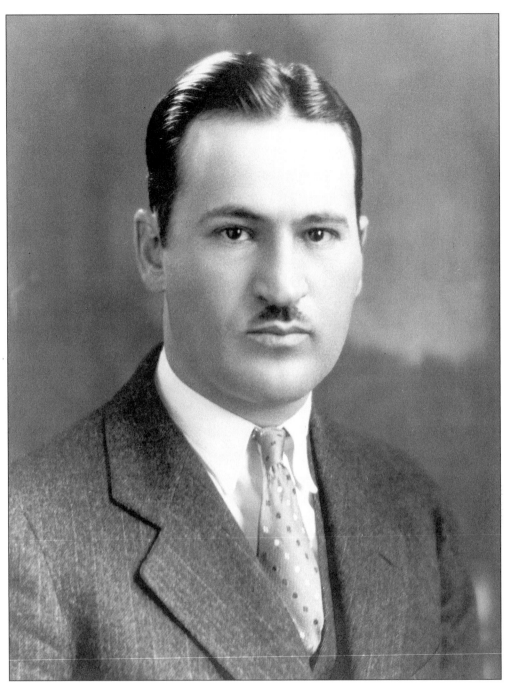

More than anyone, Herbert D. Welte personifies the growth and change in the institution during the 20th century. Arriving as a young principal in 1929, he served during the last years of the Normal School, through the entire period of the Teachers College, and the formative CCSC years. During his administration the student numbers increased tenfold. And whereas the Normal School gave only diplomas, the college Dr. Welte left in 1968 was granting a wide range of undergraduate and graduate degrees. It is no wonder that he came to be recognized as a national leader in teacher education.

Two

TEACHERS COLLEGE OF CONNECTICUT

The TCC period lasted little more than a quarter of a century—from 1933 to 1959. Nevertheless, it was a critical period in the maturation of the institution. Achievement of collegiate status, and with it the right to confer bachelor's degrees in education, was a major stride forward. Not only were there to be degrees but also new programs at the secondary level that would attract men again, programs such as Industrial Arts Education.

But the period was not without serious problems. First, the college had been created during the Great Depression, and enrollments were inevitably low in the 1930s. Then came World War II, which virtually denuded the campus of males. It would be 1946 before TCC really began to grow and prosper, and the next decade would see Dr. Welte's firm hand continuing to guide the institution toward a new level of academic credibility; from 1948 to 1958, TCC doubled in size.

Images from this period are derived to a considerable extent from the yearbook, the *Dial*. This was the time of the well-organized annual with its obligatory photographs of faculty, seniors, student activities, and the like. There was, on the other hand, nothing that could pass as a college archive of institutional photographs. You will, therefore, see here what the students saw at the time.

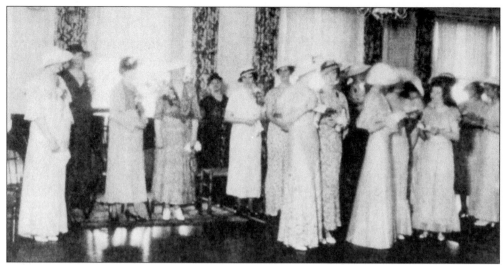

Depression or not, grace and good manners prevailed into the 1930s. The time: 1936. The place: Marcus White Living Room, which was the center of proper teas. This one is noted as "Mrs. Welte's Tea," and it certainly had the air of elegance and formality. The guests are not identifiable, but they surely included the faculty wives as well as the gentlewomen of New Britain who were friends of the Weltes.

The right to award baccalaureate degrees had been granted in 1933. Within a decade, Dr. Welte was campaigning for graduate programs in education and the authority to grant the M.S. This ability came in the early 1950s. In the meantime, several years before that, the college was admitting "post-graduate students" (who were not identified). Some of the mature students in the late 1940s were teachers in service who had completed the old three-year certificate before 1933 and were looking for their first degrees. State standards would soon require the master's degree for teachers, or at least 30 hours beyond the baccalaureate.

Artist at Work On Mural at Teachers College

As part of a WPA Project, artist/illustrator Milton Bellin was commissioned to paint murals on site in the main hall of the administration building. Class gifts from the classes of 1937 and 1938 consisted of donations for materials for these murals. In the early 1980s, David Ross, then director of the student center, arranged to save the murals from the dumpster and gained funding to have the works preserved and displayed in the Student Center, where they are today.

One way of assessing the male-female ratio by 1942 is to look at group shots in the *Dial*. Granted, women had always outnumbered men, but the odds were definitely improving from a male perspective. The situation was not going to improve for years—from the girls' perspective.

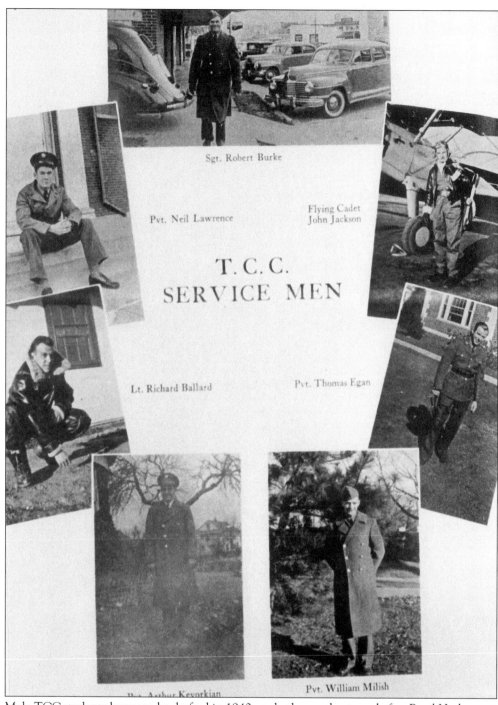

Sgt. Robert Burke

Pvt. Neil Lawrence

Flying Cadet
John Jackson

T.C.C.
SERVICE MEN

Lt. Richard Ballard

Pvt. Thomas Egan

Pvt. Arthur Kevorkian

Pvt. William Milish

Male TCC students began to be drafted in 1940, and others volunteered after Pearl Harbor was attacked. It is, therefore, not surprising that as early as the 1942 *Dial* there were a half-dozen servicemen whose pictures were available to reproduce.

Boys In Service

Ahern, Larry J., Pvt.
Ambrose, John P., 2nd Lt.
Anderson, Homer G.
Anderson, Stewart, Pvt.
Anderson, Walter J., Pvt.
Andrukiewicz, Walter
Anthony, Everett, 1st Lt.
Apisso, Joseph Paul, Instructor
Ashton, Robert L., Pvt.
Ballard, Richard E., Lt.
Ballard, A. Winthrop, Civilian Instructor
Barba, Andrew M., Lt.
Barnhardt, George W., Pvt.
Barton, John C., Corporal
Bass, Zalman, Pvt.
Beckwith, Robert, P.F.C.
Beechinor, Robert M., Captain
Blake, Austin W., Pvt.
Booker, Bruce H., Lt.
Booth, Richard, Pvt.
Bouchard, Louis M., Pvt.
Bowker, Alan M., Q.M. 3/c
Bowman, John R., Sgt.
Briere, Raymond A., Lt.
Brown, Burton F., P.F.C.
Burke, Robert M., Flight Officer
Cabelus, Thomas Peter, Pvt.
Carino, Joseph, AV/c
Carpino, Ernest C., Cpl. Tech.
Carroll, Thomas L., Capt.
Carter, Frank R.
Carter, John E., Cand.
Casey, Robert T., Pvt.
Cassidy, Robert R., Pvt.
Castiglioni, Aldo, P.F.C.
Chaffee, Roger T., 1st Lt.
Chapin, Harold C., Cpl.
Clark, Sheldon H., Appr. Seaman
Cohn, Harry, Lt.
Cohn, Leonard, Lt.
Conlin, Edward A/C
Conway, John, Pvt.
Coletto, Martin, Captain
Cook, William T., Pvt.
Crowe, Jack, Pvt.
Davidson, Emanuel, P.F.C.
Donahue, Edward F., Pvt.
Dooman, James, AV/C
Dorsey, Robert, Corporal
Drake, Edward S., RT3/c
Dudding, Walter F.
Egan, Thomas P., Sgt.
Elovich, Harold S., Pvt.
Ensign, Allan C., Tech. S.

Erwin, David, Pvt.
Falk, Harry, Pvt.
Feirstein, Isadore, Corp.
Ferguson, John J., Pvt.
Flanders, Thomas G., Pvt.
Fleitzer, Mark, Pvt.
Foran, John B., Pvt.
Forte, Andrew M., Pvt.
Fryer, Willis J., Sgt.
Freysinger, Robert, Pvt.
Fuller, Frederick O., Sgt.
Gaudette, George T., AV/C
Gerent, John J., Corporal
Goral, Raymond W., Avn. Cadet
Gorman, Daniel F., Lt.
Grace, Robert B., Corporal
Harrington, Robert, Pvt.
Hattings, J. F., 1st Lt.
Heline, A. F., Pvt.
Hicks, John C., Pvt.
Hotchkiss, William C., Pvt.
Ingelido, Michael J., Lt.
Jackson, John D., Lt.
Jaffe, Herbert
Jestinsky, Heime, Lt.
Jones, Fremont C., S/S
Kane, Leonard C., A.S.
Katz, David, Pvt.
Kelly, James R., S-2/c
Kevorkian, Arthur H., Av/C
Klopp, John F., M.S.
Kuha, William, Pvt.
Lang, Hubert G., Corp.
Larson, Arthur H., Pvt.
Larson, Edward S., Pvt.
Lattanzio, Valle, Pvt.
Lawrence, Neil A., Sgt.
Lee, Robert, Pvt.
Legnard, George P., Corp.
Light, Mason E., Lt. j.g.
Lose, Russell D., Tech. Sgt.
Lukens, Robert C., Lt.
Lynch, Robert T., 1st Lt.
Mahoney, Douglas Burson, LAC
Maikowski, Henry, Cadet
Manning, William Howard, Corp.
Marino, Guido, Pvt.
Matulis, Raymond G., Sgt.
Mayer, Walter F., Cand.
McGrath, Lawrence J., Pvt.
McInerney, William R., Pvt.
McIntyre, James D., P.F.C.
McMahon, Edward, Pvt.
Meotti, Louis J., Sgt.

Meyer, Winfred A., Warrant Officer
Michaelis, Raymond A., A/C
Milish, William H., Cadet
Moxley, Robert R., Pvt.
Naughton, James J., Jr., A/C
Nordgren, G. Robert, Pvt.
Norkin, Irving, Pvt.
Perkel, Leo, Pvt.
Peterson, Ernest H., Corp.
Piechulis, Antony A., Corp.
Pivnick, Herbert L., Pvt.
Plocharczyk, Walter J., A/C
Preble, Frank, P.F.C.
Pulito, Anthony J., Pvt.
Radune, Albert, Ensign
Reale, Paul J., Apprentice Seaman
Redfield, Levi G., Lt.
Rettie, Charles S., Lt.
Rothstein, George A., P.F.C.
Richman, Seymour M., Sgt.
Self, Charles L., Jr., Pvt.
Shapiro, Bernard, 2nd Lt.
Siegel, Harry, Pvt.
Siegel, Paul, Pvt.
Silks, Edward J., Lt.
Skilton, Rollin W., Cadet
Sorenson, Robert L., Pvt.
Stanley, Howard W., Pvt.
Stearns, Joseph B., A/C
Stein, Michael W., Pvt.
Strauss, Albert Victor, Staff Sgt.
Streiblg, Kenneth C.
Strom, Charles, Pvt.
Stuart, Robert A., Sgt.
Sujdak, Robert, Pvt.
Tanguay, Phillip O., Pvt.
Taylor, Schuyler J., 1st Lt. a/c
Theer, William, A/C
Tucker, Lewis B., Pvt.
Tyler, Eugene, A/C
Vecchiolla, John A., Pvt.
Vouras, Paul, Pvt.
Walker, K. B., Pvt.
Wason, Robert C., 1st Lt.
Watson, George E., P.F.C.
Webb, Rogert Lambert, Appr. Seaman
Wick, Walter O., Lt.
Wilber, George H., Sgt.
Wilber, Irving W., P.F.C.
Willcox, Leonard B., S-3/c
Wiehart, William H., Cadet
Zajac, Benjamin, Pvt.
Zubretsky, John M., T.S.

The few men who were depicted in 1942 had become the many by 1943. Volunteers and draftees now represented a significant portion of TCC's male population. And it should be remembered that this was only 1943. Inductions would continue into 1945. Consequently, this is not a full list of TCC's servicemen. What purports to be a full list has been on display in the foyer of Davidson Hall since the end of the war.

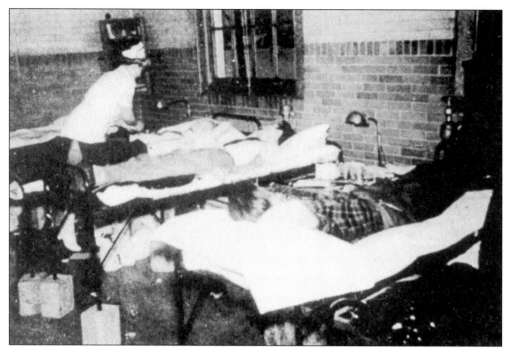

Even those who remained in college were participants in the war effort. A common—and necessary—activity was the blood drive. This one took place in 1943. Students, faculty, and staff alike were encouraged to give blood. Obviously, some did.

In 1946 the war had been over for almost a year, yet men were still conspicuously absent from the graduating class. There appear to have been 52 women and four men. True, the male population had begun to increase in the autumn of 1945, but the Class of '46 shows the effects of the absence of males during the war years.

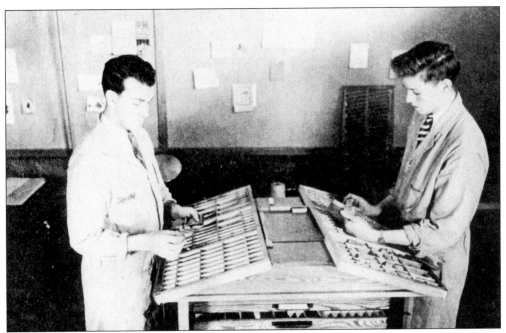

The acquisition of East Hall in 1946 provided relatively spacious quarters for the Industrial Arts Department. Setting type by hand was a less than high-tech operation, however, no matter where it was done. In 1953 the department would move to new Barnard Hall, where type would still be set by hand.

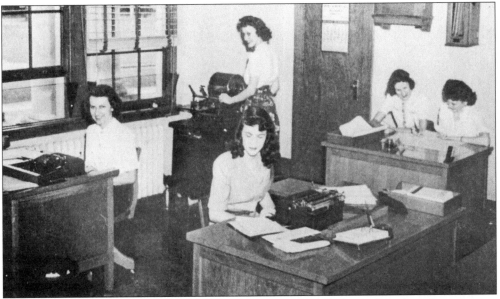

During the early postwar years when instruction was virtually limited to the administration building and the downtown Rockwell School, the office staff for the main campus included six secretaries and a mimeograph machine. The office also accommodated the telephone switchboard, and faculty mailboxes were in the corridor outside.

FRESHMAN INITIATION RULES

1. Freshmen must have two name cards 9" by 12", and they must be worn on the back and front of the person. The letters must be 2" thick and printed in red ink. Nicknames must also be included.

2. One green sock and one white sock must be worn each day (green and white in honor of the Sophomore class colors).

3. Books must be carried in a bag.

4. Shoes must be taken off when entering the library.

5. Freshmen must open and close all doors for the Sophomores.

7. Smoking by the Freshmen is prohibited, but they must carry matches just in case the Sophomores run out of them.

8. T.C.C. must be written with dark red lipstick in letters covering the entire forehead.

9. Freshmen must be able to sing the SOPHOMORE CLASS SONG and YOU ARE MY SOPHOMORE.

10. Freshmen will not be allowed in the court during initiation week nor may they use the main entrance of the building.

11. Freshmen must wear good-sized bibs at all meals.

12. All Freshmen must carry materials for shining shoes because some of our Sophomores do not have the time to polish their shoes.

These rules are to take effect on the 24th of September and last through the 26th of September. They must be observed on the campus from 8:30 A.M. to 5:00 P.M. Commuters will be excused from these rules while riding to and from the campus.

Freshmen should watch the bulletin board daily for any additional notices about the rules for the day which will be added to those already given above.

The 1930s-style hazing of freshmen continued after the war. This was 1947, a year when mature veterans were starting college under the GI Bill. There is no record of how they responded to the authoritarian sophomores.

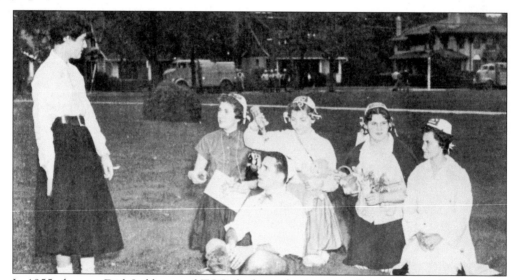

In 1955, the year Dick Judd entered TCC, freshman hazing was still going strong. Beanies were universal for the freshmen, and pigtails were expected of girls. There is no evidence, however, that shampoos were a regular occurrence for men. (Note the sophomore's hemline: the "new look" was still in.)

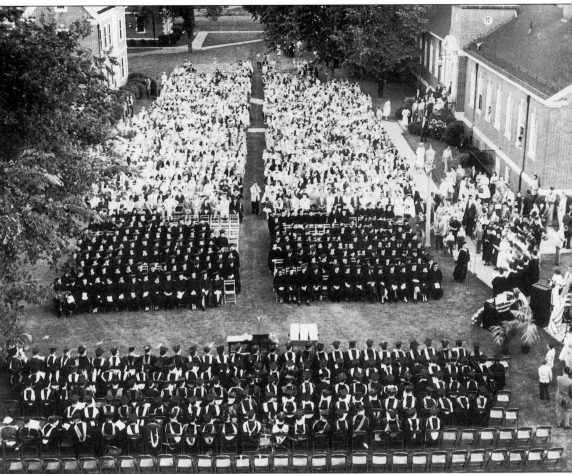

Before the enrollment exploded in the 1960s, Commencement was held in the area between the administration building and Marcus White Hall. This is a picture of the 1952 ceremony. Note the number of empty seats in the faculty section. To ensure full faculty participation, Dr. Welte subsequently had faculty attendance taken. (The author is identifiable in the back row because he had flipped his hood over the chair back to keep from crushing a part of his rather new regalia.)

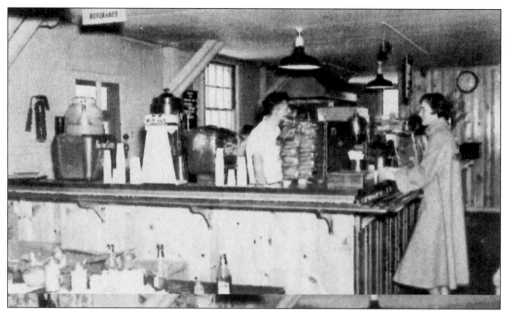

There was not a student center on the campus until 1964. During the previous 15 years, the closest approximation was the East Hall lounge. The amenities were primitive in the temporary building, but at least it was a place to eat lunch and play setback.

There were three student gathering places within walking distance of the college. One of these, the Spa, was a restaurant and bar in the Belvidere shopping plaza. Owned by Stanley Nadolny, it provided not only a place for faculty to have morning coffee, it was the nearest source of alcohol. Given the mores of the times, the clientele was mostly male. (The drinking age was 18 in those days.)

The second of the three places was the Belvidere Drug. Like the picture of the Spa, this was a scene from 1947. The drugstore was primarily a pharmacy but did have a soda fountain. As this photograph suggests, it was more attractive to women as a social gathering place. (Jerry Wellins, the proprietor, did sell alcohol but only by the bottle.)

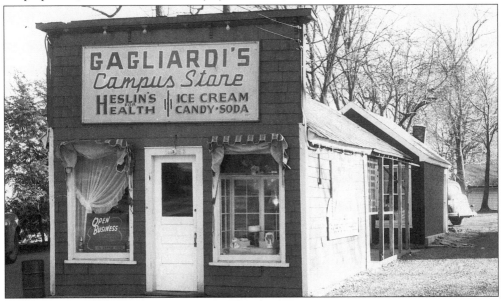

The third place was the closest to the school. It was adjacent to the campus, as the campus was at the time, and stood on Stanley Street roughly between Willard and DiLoreto Halls. It was the closest thing to a fast-food place around, food being served in the connecting building at the rear. It also served as a convenience store where you could buy your *Herald-Tribune* or your birch beer.

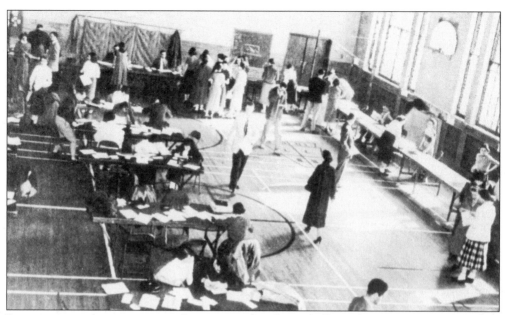

Registration in the postwar period was a pencil and paper affair. The venue was the women's gym in the administration building, and students went from departmental table to departmental table looking for courses—and not infrequently shopping for particular instructors.

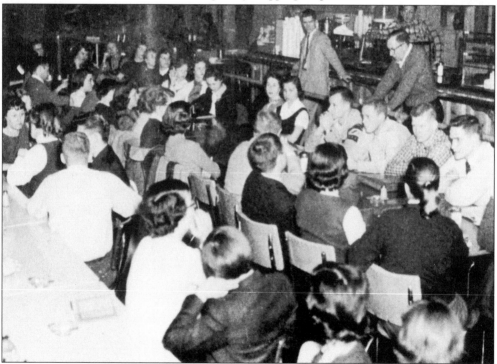

This is a student rally from 1956, not a student demonstration from the 1960s. The issue? Students were being exhorted not to take teaching jobs where the starting pay was less than $4,000 annually. By and large, the students held their ground, and better starting salaries became the norm.

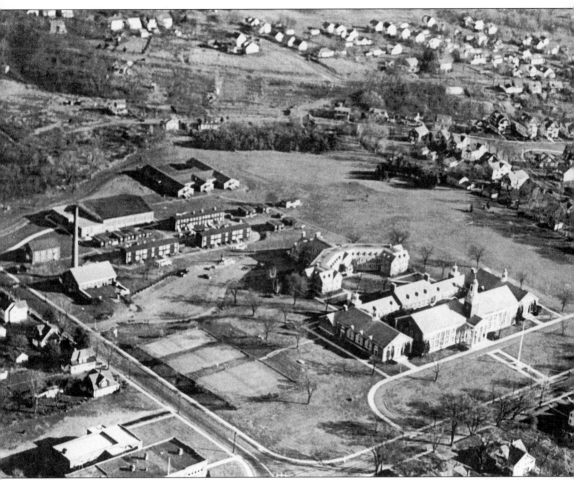

Immediately after World War II, major physical changes occurred. In addition to the new (men's) gymnasium, "temporary" buildings were moved in from Bradley Air Base. They included East Hall and various barracks and trailers for temporary housing. In addition to housing, the trailers provided a home for the campus radio station (WTCC) and an office for three members of the Education Department faculty.

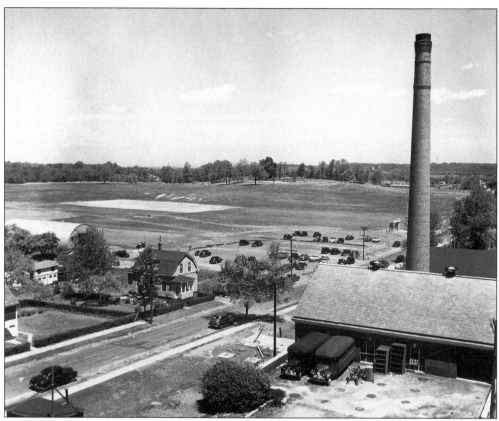

Another sign of growth in the late 1940s was the fact that the college was expanding physically across Wells Street. At this point, houses still dotted the street from Stanley School to the turkey farm, but the parking lot was a harbinger. Arute Field would soon be followed by the student center and Welte Auditorium.

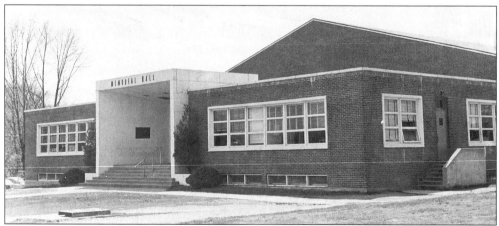

Memorial Hall was the first new building on the campus after World War II. It was designed exclusively as a men's gymnasium and athletic facility. There were classrooms at the front for courses such as community recreation and showers in the basement, but essentially it was one good-sized basketball court with spectators' stands. It survived until Kaiser Hall was constructed.

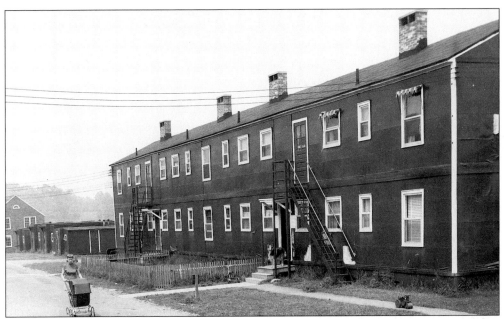

In the immediate post-World War II period, there was a population surge—veterans with families and new young faculty. The temporary accommodations included barracks and trailers moved from Bradley Field. The building pictured, one of three, housed eight families. The rent was $40 a month and included all the hard coal you could burn. Bottled gas for cooking and hot water were extra.

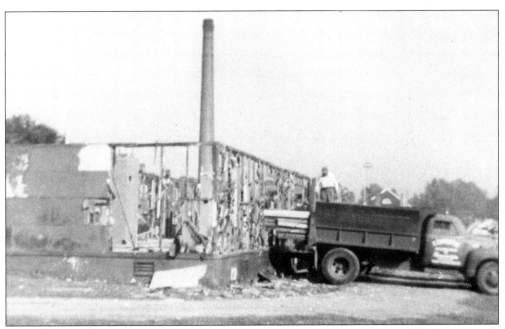

In September 1955, the barracks, having outlived their usefulness, were demolished. It is worth noting, though, that there was still no real men's dormitory.

The mess hall at Bradley Air Field became a multi-purpose facility for TCC when it was moved and reassembled to help meet the postwar enrollment growth. (By 1950 enrollment was up to 1,000 students.) Now called East Hall, it served variously as the library, the home of the Industrial Arts and Music Departments, and the student lounge. It ended as a maintenance building before its dramatic end, which is shown elsewhere.

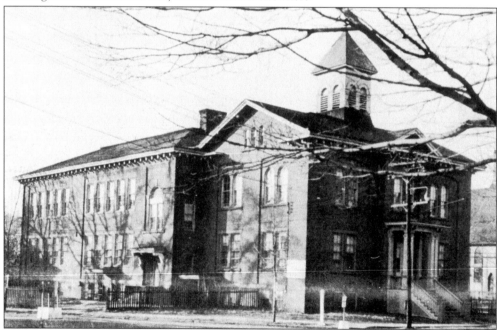

With the serious influx of veterans beginning in 1946, the College was desperately short of academic space. The solution was found in a vacant old elementary school building in downtown New Britain. The Rockwell School was the home of the English and Social Science Departments until 1953. For ease in scheduling, classes began at Rockwell on the hour and on the half hour at the main campus. The college ran a shuttle bus between the two.

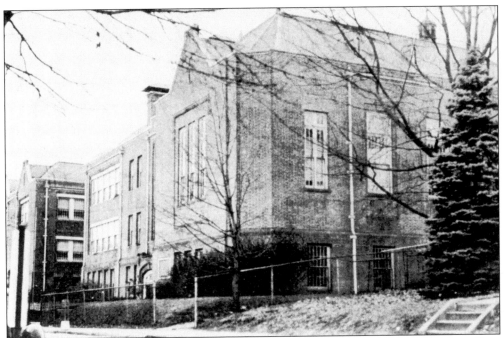

Camp School was one of the three laboratory schools in New Britain managed by the college for the training of elementary teachers. It was the closest of the three to being an inner-city school and was located very close to what had been the second Normal School building.

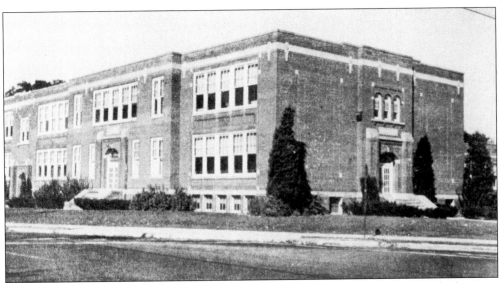

Stanley School, built in 1921, shortly before the new Normal School was built in Belvidere, was situated on the corner of Stanley and Wells Streets. It was, therefore, ideally located to serve as a training school for elementary teachers. It served as such for more than 50 years. Abandoned, it fell into disrepair until it was remodeled and converted to a home for the Art and the Theatre Departments. It was renamed for James Maloney, the Broadway and Hollywood actor who served for some years on the CCSC staff.

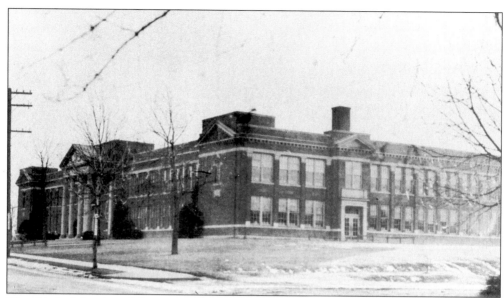

The third of the three laboratory schools was Vance. If Stanley represented the convenient neighborhood school, and if Camp was the nearest equivalent to an urban inner-city school, Vance was the "gold coast" institution. It was situated in an upper-middle-class neighborhood in New Britain's West End. For many years its principal was the redoubtable Eleanor Mackinnon.

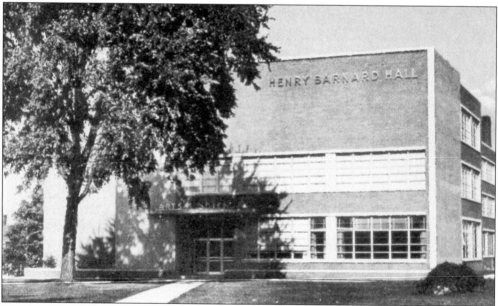

The first new classroom building to be built after the war was Henry Barnard Hall. It received legislative authorization in 1949, and the main portion was occupied in the spring of 1953. While the building was under construction, a legislative amendment was introduced ("sneaked in" is a more accurate way of putting it) to limit the building's use to the preparation of elementary teachers only. Considering that the building was designed for industrial arts, all the sciences, and art, this became an issue in the war with UConn over the training of secondary school teachers. TCC won.

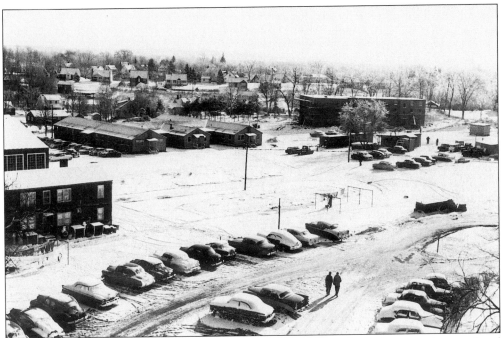

This scene shows the campus very much in transition. Taken from the recently completed Barnard Hall, this photograph shows the barracks for married students and young faculty, East Hall, and the newly constructed Seth North Hall. The transition? The barracks were soon to disappear, and North represented the beginning of major dormitory development on the south side of the campus.

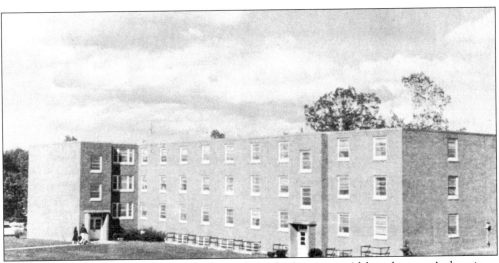

For nearly 30 years, Marcus White Hall was the only dormitory. Although a men's dormitory was in Dr. Welte's plan for campus expansion, there was none until the mid-1950s. Males had lived under supervision in the Rockland Project at the far end of town since the war, but Seth North was the first proper campus residence for men.

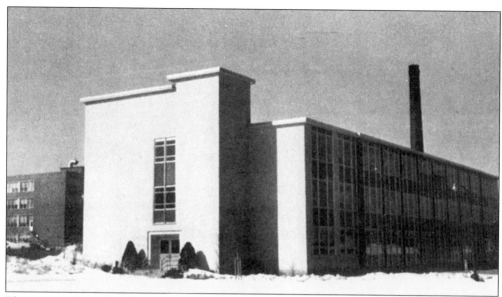

The next academic building after Barnard Hall was Maria Sanford, named for an alumnus of the Normal School who was one of the first female professors in the U.S. Its late 1950s design was considered to be either quite modern or the beginning of questionable architectural taste. Like many another state project, it was under-funded. From the third floor, there are stairs to nowhere; there was originally supposed to have been an additional floor. It was never added.

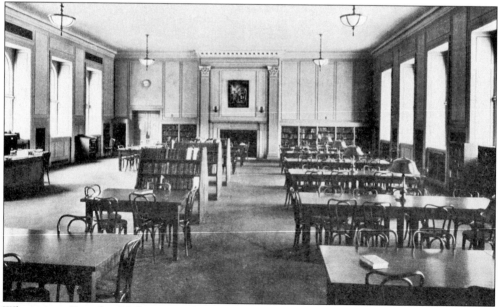

What is now Founders Hall was, until 1959, the main reading room of the library (or at least the reserve room when the reading room was located in East Hall). If it looks as if there were very few books, that is not far from the truth: the library was once rated unacceptable in an accreditation visit. There were, in fact, books in adjacent rooms.

Following the AACTE criticism of the library in 1951, the pursuit of a new facility became a serious legislative priority. With the help and support of Paul Amenta, an alumnus and state senator from New Britain, a deal was struck in which TCC got its library and UConn got E.O. Smith High School. The building was finally occupied in 1959 during the transition to State College status.

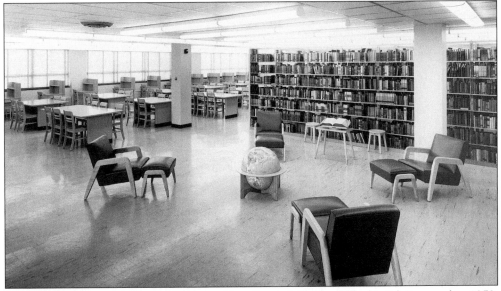

The new library, named for Elihu Burritt, New Britain's "learned blacksmith," opened in 1959. On the top floor, it housed the English and Social Science Departments, and the media center was in the basement. In between was a much-needed library, furnished with plastic-modern decor. Compared to the size of its predecessor, the new facility seemed to have tremendous possibilities for expansion. But that was when the enrollment was around 2,000. The new library was soon outgrown.

The transition from Teachers College to Connecticut to Central Connecticut State College took place in 1959–60 as a result of legislative recognition that it was no longer simply a teacher-training institution. (The right to grant the B.A. degree did not immediately follow, on the logic that students would require time to complete the new programs.) Eventually the campus was appropriately signed.

Three

THE CENTRAL YEARS

The creation of Central Connecticut State College by the general assembly in 1959 ushered in yet another chapter in the development of the institution. The empowering legislation gave the teachers colleges the right to develop B.A. programs, thereby acknowledging that they were no longer single-function institutions. Enrollments exploded, partly because of the demographics of the 1960s, partly because of the wide range of academic programs that could now be offered, and partly because the community-technical college system had not yet grown to any size.

Consequently, the enrollment mushroomed to 8,000 in 1973, and the College outgrew its physical plant as fast as it could be built. This is very clear from the photographic record of the 1960–75 period. Although some construction had been undertaken toward the end of the previous decade, new buildings were now virtually an annual event.

There were campus issues in the CCSC period—Vietnam protests, racial unrest, even the threat that faculty would have to pay to park. The major institutional change was the elevation to the status of University in 1983, and the period also saw the transfer of leadership from Dr. Welte to F. Don James to John W. Shumaker to Richard L. Judd. The university archives are the primary resource for this period.

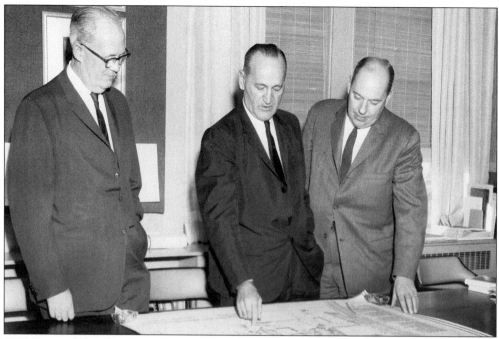

CCSC moved into the 1960s as an expanding institution with little or no planning. Looking to the future, Harold Bingham, executive assistant to the president (left), spearheaded a serious planning effort, which was generally followed during the next phase of expansion. Looking at the master plan with him are President Welte and Vice President for Academic Affairs H.B. Jestin. The major deviation from the plan to reality was the combining of separate Science and Technology facilities into a single building—Copernicus Hall.

The gymnasium in the administration building served both women and men until 1946, when Memorial Hall was built. It then became the women's gym but was also used for mass registrations. With the completion of Kaiser Gymnasium, the old facility was massively converted: a second floor was erected for Fiscal Affairs and Purchasing, while the old floor was modified to house Admissions and the Registrar. The photograph above depicts the conversion process before the old spectator balcony had been removed.

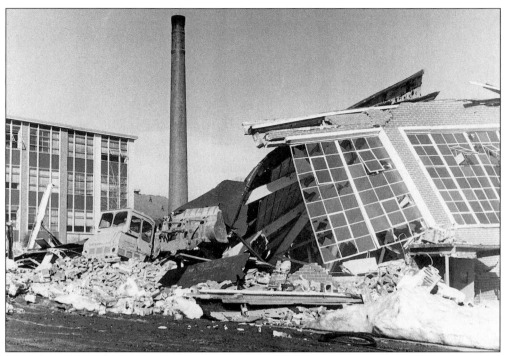

Old Memorial Hall, the first permanent building added to the campus after the war, was the victim of College growth. Need for it was reduced by the completion of Kaiser Hall, a much bigger and better athletic facility, and the old gym was demolished in 1968 to make way for the new Memorial Hall—the present food service facility. Recognizable are, of course, Maria Sanford Hall and the powerhouse smoke stack.

With new dormitories appearing on campus, the old dining room in Marcus White was outgrown, and a new cafeteria was built as an annex to Marcus White Hall. It remained the cafeteria for more than ten years before being recycled as the home of the Art Department and the major computer lab, among other things. In its early days, the building housed the rifle range in the basement.

Following the completion of Seth North, the men's dormitory, additional dormitories—both men's and women's—were built at a fairly rapid rate. These were part of Harold Bingham's plans for capital expansion when he was executive assistant to Dr. Welte. Although academic buildings were still expected to be funded by legislative appropriations, these dormitories and other auxiliary facilities were authorized as self-liquidating projects.

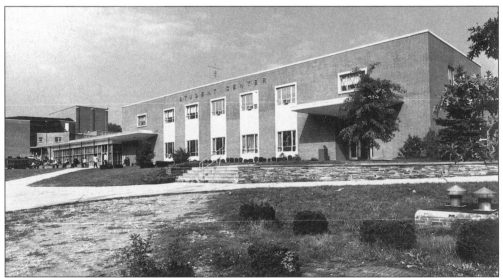

Part of the major construction projects had spread across Wells Street. By the early 1960s the enrollment had begun to mushroom, and a student center was a serious need. The facility was opened in 1964 with Dick Judd as director. Although plans were put forward from time to time to expand the facility vertically, it never happened. Only in the sesquicentennial year will the significant renovations begin.

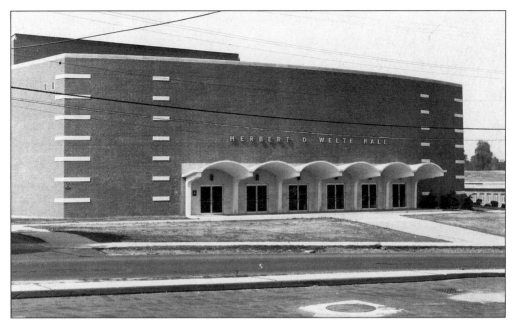

Since the 1920s the auditorium in the administration building had been the only place for performances until 1963. The new facility was named for President Welte—a rare accolade because public buildings are not generally named for persons still in public service. The new building not only could seat nearly 1,900, it also housed the Music Department. This can be said to reflect the influence of Etzel Wilhoit, Music Department chair and the director of the New Britain Symphony. Effectively, the place was designed for music, not theater. Ironically, the acoustics were initially wretched.

Frank DiLoreto Hall was finally occupied in 1968 after a series of problems in its construction. (It was named for the New Britain state senator who had been instrumental in pushing CCSC's capital agenda in the legislature; he died young.) The building was a disaster from the start. As usual, the delay between the original appropriation and the construction required that the building be somehow reduced. The building was being designed for the Social Sciences, and the then chairman made a fateful choice: instead of reducing the number of floors, his solution was to foreshorten every room, making the classrooms wider than long. It has, therefore, always been a wretched place to teach.

59

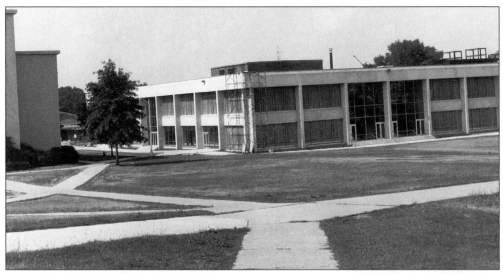

Once old Memorial Hall had been demolished in 1968, space was available for a major new food service building. The annex to Marcus White Hall had served during the expansion period of the early 1960s, but it had become outgrown. The new facility provided dining facilities not only for resident students but also for faculty. There were also rooms for university dinner functions and some space for other student services. Even with the nice new facility, students continued to complain about the food.

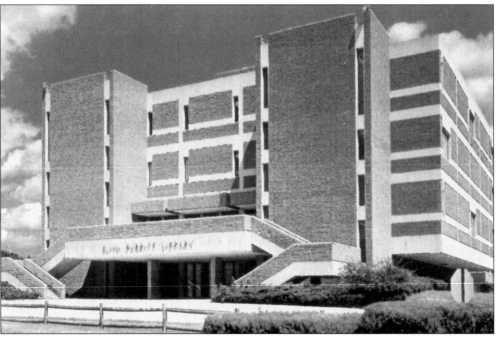

A cornerstone of Harold Bingham's master plan was a new, larger library. The first Burritt Library (later named Willard) was outgrown in little more than a decade. The new Burritt Library, occupied in 1972, was designed for even greater expansion. At the dedication, President James is alleged to have said to the governor, "We need more books. Look at all the empty shelves." The governor is supposed to have replied, "You have too many shelves."

The ninth leader of the institution, F. Don James arrived in the fall of 1968 following the retirement of Dr. Welte. Dr. James had previously been interim president at the University of Rhode Island. His scholarly work had been in the area of Biblical studies, especially the Dead Sea Scrolls. Under his administration CCSC achieved all-time high enrollments, and he oversaw the overhaul of the academic administration. It was under his presidency that Central became a university. He retired in 1986.

After 40-some years in the administration building, the telephone switchboard was moved to Barnard Hall. Peggy Pasco is seen as the operator of a fairly primitive system. It should be recalled, however, that the college had a dial system by then, and most calls did not go through the operator. What is hard to explain is why was she doing it by candlelight.

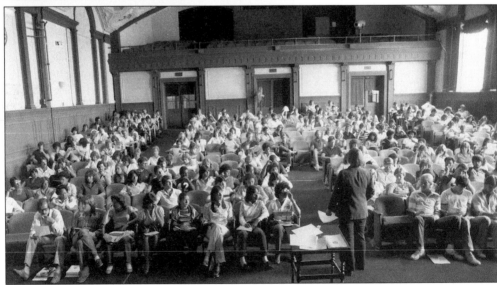

There are almost no photographs of the auditorium in the administration building taken from the stage. This one dates from the early 1970s. A few years before, the hard wooden seats were replaced by upholstered ones, bringing a certain comfort to what was by then being called the College Theatre. But the rest of the décor was done abominably, and—worse—the theatre was turned into a monster classroom with clumsy lap boards. It was a time of maximum enrollments and minimum academic enthusiasm.

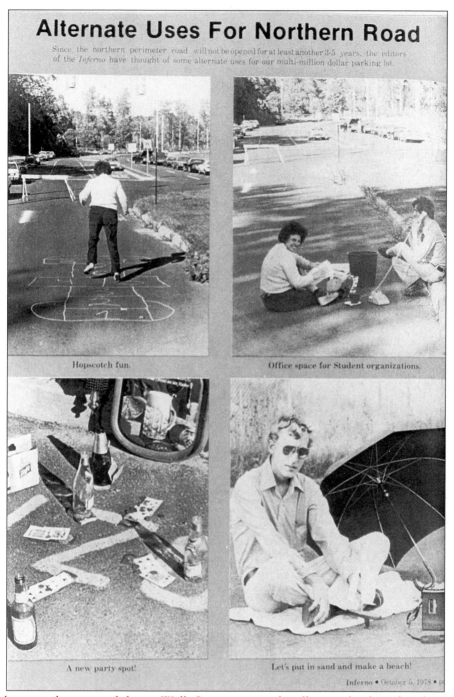

Alternate Uses For Northern Road

Since the northern perimeter road will not be opened for at least another 3-5 years, the editors of the *Inferno* have thought of some alternate uses for our multi-million dollar parking lot.

Hopscotch fun.

Office space for Student organizations.

A new party spot!

Let's put in sand and make a beach!

Inferno • October 5, 1978 • p.

The long-standing issue of closing Wells Street to general traffic was closely tied to the matter of opening the northern by-pass road, now Ella Grasso Boulevard. Complications developed between the state and New Britain over such matters as traffic lights, and the road was completed long before it was opened for use. The *Inferno*, the alternative publication to the *Recorder*, offered a variety of suggestions as to how the road might be used—other than as a parking lot, which was for years its main function.

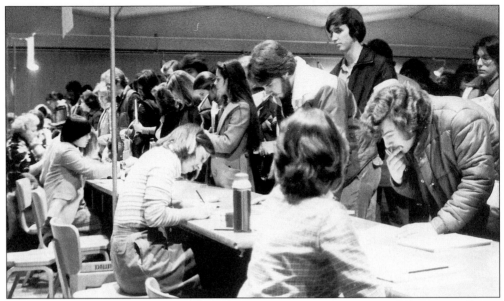

Registration became in the late 1960s and early 1970s a time of organized chaos. Enrollment was approaching its all-time peak, and the new technologies were not yet in place. The Student Center ballroom hosted long queues of students shopping for full schedules and choice professors. For many students it was a time of deep frustration.

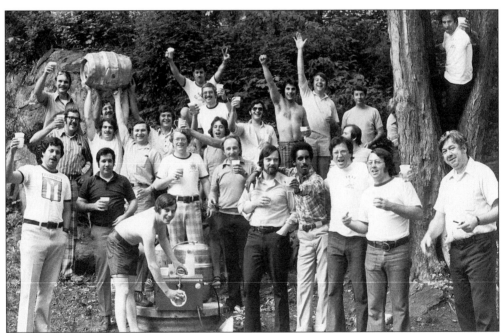

It was 1970, and the Student Affairs staff (at least the males) were having what was euphemistically called a "water safety seminar" at Lake Zoar. Can you identify, among others, Vice President Peter Rosa, Dean David Ross, Associate Dean James Jost, and Registrar James Fox ?, or former Vice President Joe Pikiell, former Chief of Security Chuck McDonald ?, or even Dick Judd?

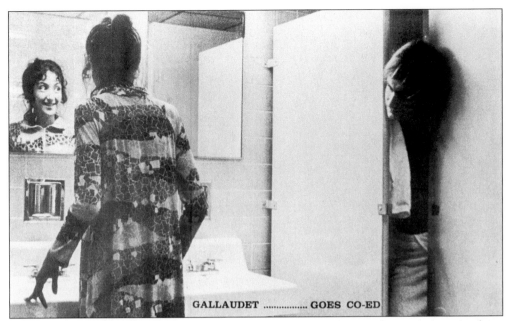

GALLAUDET GOES CO-ED

Students were concerned about things being "relevant." Students were demonstrating. Students were protesting. Students were behaving, well, differently. So was the administration. In the autumn of 1972, Gallaudet Hall was allowed to go co-ed. The *Inferno* immortalized the change in what was acceptable. Such a thing would have been unthinkable when Marcus White was a dorm and Isabelle Rupert ran it.

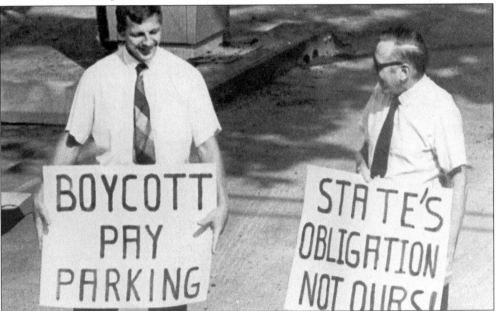

The fall of 1970 was a time of problems such as the Vietnam issue and racial tensions. But the matter that raised the greatest furor was the one concerning the proposed policy that would have required faculty and staff to pay to park on the campus. Dix Kelly was one of the leaders in the resistance movement, which boycotted campus parking and spread cars far and wide across Belvidere. The issue was finally resolved in favor of the faculty: they do not pay.

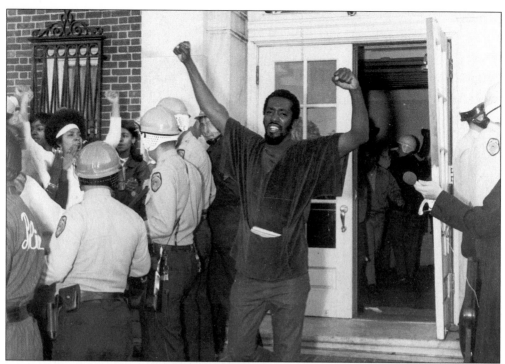

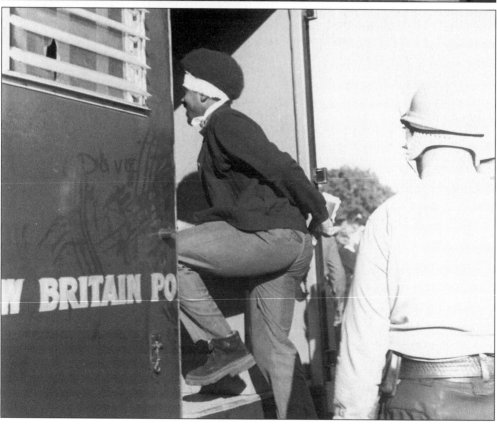

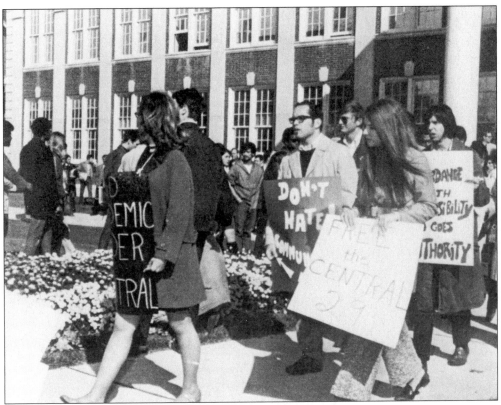

The closest thing Central had to a 1960s-style demonstration occurred in 1969. The relatively small minority student community—mostly African Americans and a few Puerto Ricans—had been peacefully airing grievances relating to perceived discrimination and lack of institutional support. The crisis came when a male in a dormitory threw a bottle out of a dormitory window and shouted a racist epithet at a passing African-American female student. When neither the campus nor local police reacted decisively, the minority students erupted and briefly took over the administration building.

Shown at the top of the opposite page is Larry Montgomery (Babatunji) leaving the building after the police had taken control. Below is a photograph of one of the demonstrators being ushered onto a police vehicle after her arrest. Twenty-nine demonstrators in all were arrested. The counter-protest, involving mostly white demonstrators, expressed support of those arrested, demonstrated by the sign: FREE the CENTRAL 29.

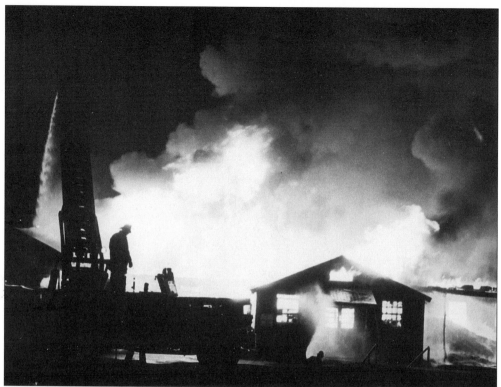

East Hall had been moved from Bradley Air Field just after the war, and, as has been noted, it had been an all-purpose facility over the years. Variously it was used for the library, instructional purposes, student lounges, and, latterly as a maintenance building. On the night of April 1, 1975, it burned or was burned. No cause was ever established.

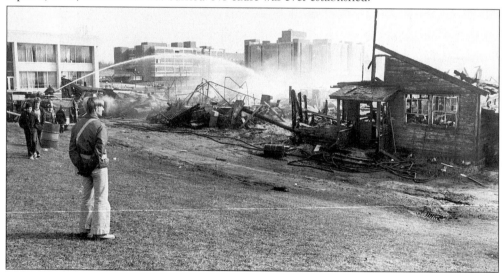

The aftermath is obvious. The old building with a large peace sign painted on its roof was rubble. Gone, too, were many of the campus building plans and much of the maintenance equipment. For years it was common to hear that missing materials "had gone in the East Hall fire."

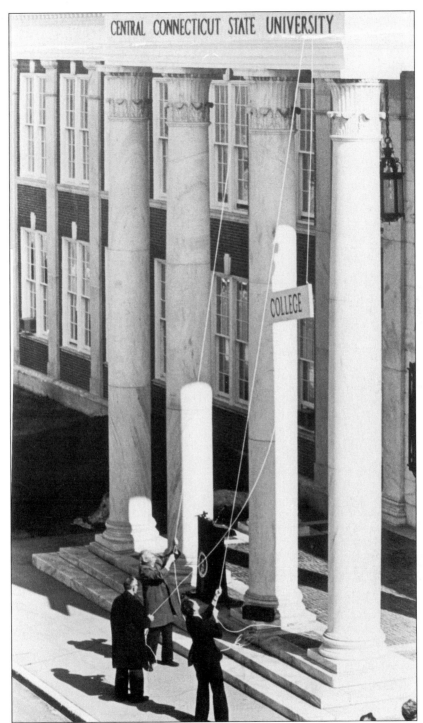

U-Day! On March 1, 1983, the college celebrated its new status as a university. In preparation, the word "College" had been replaced by "University" on the front of the administration building, and a painted board saying "College" was used as a temporary covering. On the big day, the board was lowered to reveal the new identity.

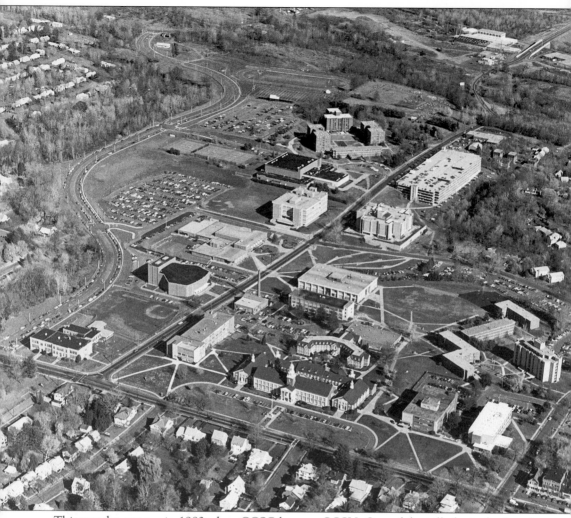

This was the campus in 1983 when CCSC became CCSU. One of the telltales is the fact that Ella Grasso Boulevard was still a parking lot; it went nowhere. Yet to be constructed were the parking garage north of the library and a new dormitory, James Hall. Still to be done as of 1999: a major classroom building and renovation of the student center.

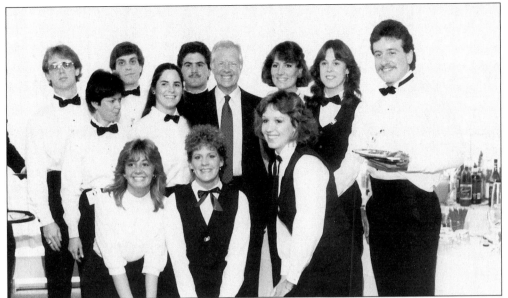

A major cultural event held almost annually since 1983 has been the Vance Lecture. Named in honor of Robert Vance and supported by the Vance Foundation, it has provided the opportunity to bring people of international stature to the campus. Examples are Ben Bradlee, Henry Kissinger, and Harold Lord Wilson. Pictured is one who filled Kaiser—Jimmy Carter, seen with the wait staff at the reception.

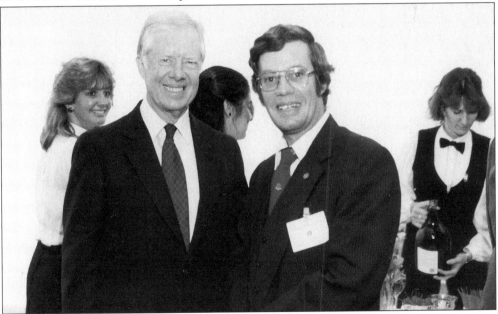

When former President Carter was on the campus, there was competition to be photographed with him, especially if one were a card-carrying Democrat. One such was James Jost, associate dean of students. Jost, a Central graduate, had been on the Student Affairs staff since 1971. Among his various responsibilities he has overseen the campus medical services, but he will be better remembered by students for his presiding over judicial hearings—not the happiest time for the students involved.

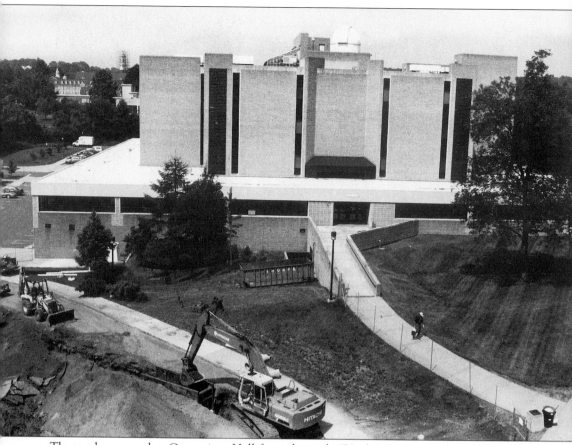

Those who remember Copernicus Hall from the early '70s (or even more recently) will look twice before identifying with certainty this home for the Natural Sciences and Technology Departments. After a hiatus of nearly 25 years, during which no academic buildings were added, Copernicus has finally received a "skirt," which would provide both offices and classroom space. This picture was taken in 1998 during the construction.

Arriving in 1987 from SUNY Albany, Dr. John W. Shumaker became the tenth leader of the institution. He sought to focus greater emphasis on research. Thanks to massive retirements in 1989 under a retirement incentive program and further substantial retirements in 1991, his administration saw the recruitment of young Ph.D.s with serious research agenda. With Henry Enck as his executive assistant, he also sought to develop entrepreneurial programs in the international arena.

During the 1995–96 academic year, between the presidencies of John Shumaker and Richard Judd, Merle Harris served as interim president. She was, in effect, "borrowed" from Charter Oak State College for the year and returned there upon the completion of her service. She was instrumental in forging close links between CCSU and Charter Oak; indeed, the latter has lately been provided a building adjacent to CCSU.

Dr. Richard L. Judd became the 11th president of the institution in 1996 after a virtual lifetime of contributions to Central. An alumnus of the TCC Class of 1959, he left for five years but returned in 1964 as a nominal instructor in psychology; his real job was director of the new student center. Early in Don James's presidency he showed skill in dealing with fractious students and was made dean of students as a result. He subsequently rose to the positions of executive dean and vice president for University Affairs. In another life he is an internationally known specialist in emergency medicine.

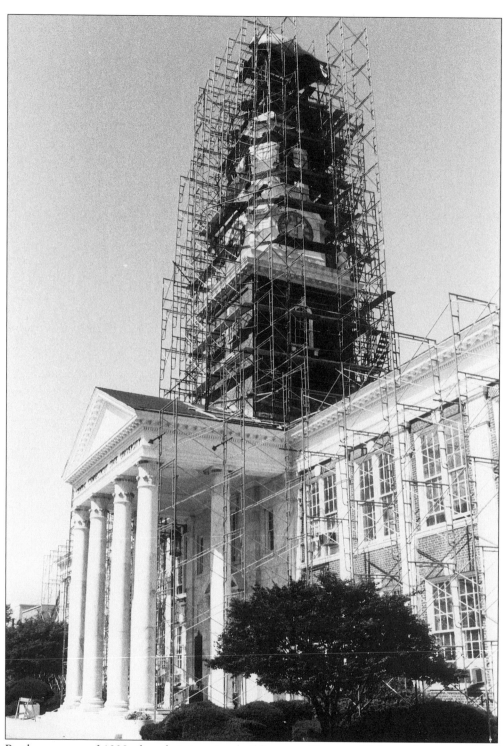

By the summer of 1998, the administration building was 75 years old. Its roof was in need of repair, and so was the clock tower. As if to be ready for the sesquicentennial, a major face lift was begun on both this building and Marcus White Hall.

Four

STUDENT LIFE

This chapter is devoted to the non-academic side of student life. Because of the availability of pictorial resources, it focuses mostly on the TCC and Central years. What it purports to do is to provide a wide-ranging overview of student activities, most of them college sponsored or sanctioned.

It would have been possible to devote a whole chapter to athletics or perhaps certain other types of activities. It seemed more faithful to the variety of student life to present only representative images of each sort of activity even though one may legitimately quarrel with which football or basketball team "made the cut." It is thus intended to provide a panoramic view of the richness and diversity of student life.

Sources for this chapter include the institution's archives, publications such as the *Dial* and the *Inferno*, and occasional contributions from private collections.

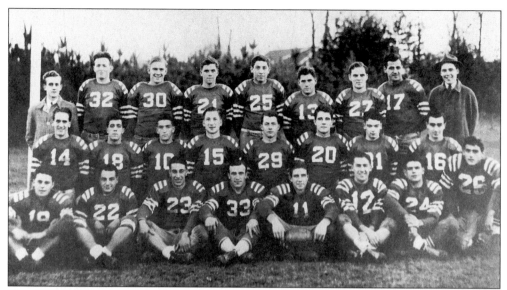

The 1939 football team was one of TCC's greatest. Coached by Harrison Kaiser, later the athletic director, the team was one of two in the Teachers College era to go undefeated. Not only undefeated, it was unscored on until the last game. With a 6-0 record, it gave up an average of two points a game.

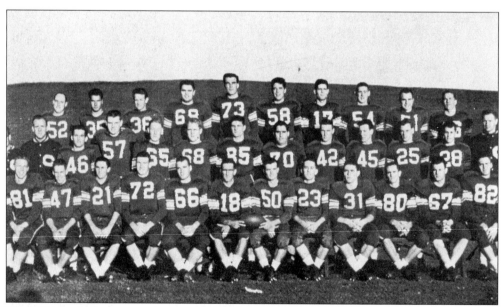

The 1954 football team was the second undefeated team in TCC's history. In a 6-0 season, only New Haven Teachers scored more than six points. The New Haven game was a cliffhanger, TCC winning by a score of 15-14. (Wins over New Haven were rare; they offered a Physical Education major.)

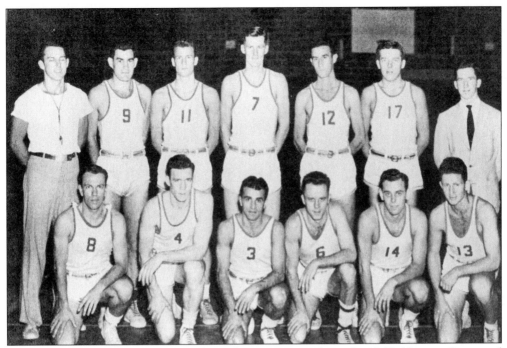

One of the great basketball teams of the early postwar period was the 1948–49 team. Captained by Ed Rosmarin and Bill Massa, it had a season record of 17-4. Three of the four losses were on a road trip to the Midwest. The only Eastern team to beat them was Siena, which had the second best defense in the country that year.

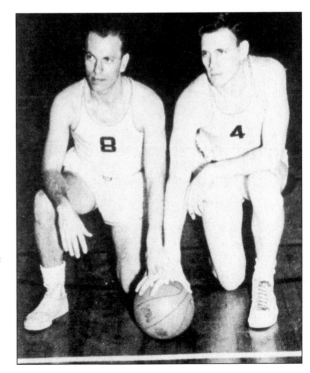

In the last years of the 1940s, Coach Ross Merrick put together some of the greatest basketball in the school's history. Pictured at right in 1949 are co-captains John Canevari and Bill Detrick, examples of out-of-state recruits Merrick could attract because tuition was only $21 a year. A third member of the team was Ed Rossmarin. All three remained in Connecticut, Detrick and Rosmarin making their careers at Central. One of the team's great games was an unofficial "exhibition" match with the Holy Cross team, which won both the NCAA and the NIT. The game was played in Waterbury under assumed names; Holy Cross barely won.

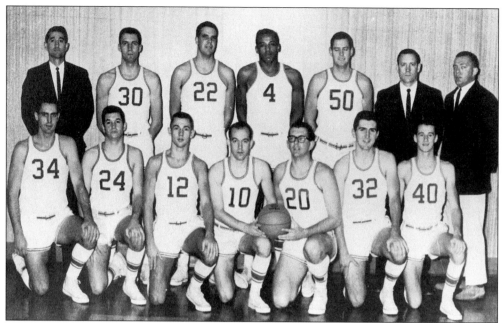

If the record means anything, the 1962–63 men's basketball team was the greatest in history. At the end of that regular season, Central was the only one of the 990 collegiate teams to finish the season undefeated—22-0. Its only loss was a 72-71 defeat in the NAIA national championships. Coached by Bill Detrick, the starting five were Bob Reagan, Dick Rogers, Dave Frauenhofer, John Pazdar, and Tom Maxwell.

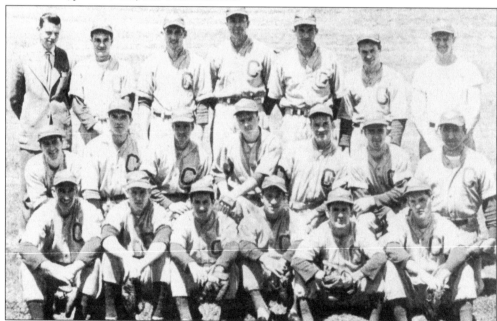

Basketball was not the only success story of the late 1940s and early 1950s. Hank Majlinger's team in the 1951 season compiled a 13-1 record. Featuring Dick Fitzpatrick and Tuck O'Brien as the primary pitching/catching combination, it also had power. TCC beat Willimantic 17-6 and Fitchburg 24-4.

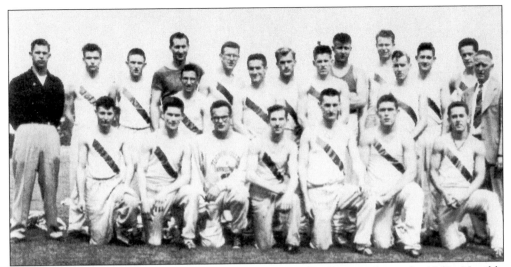

Coach Ted Owen's track teams were powerhouses in small college circles in the 1950s. Notable was the 1954 team, the first undefeated track team in TCC's history. The season's outstanding performance was turned in by Don Luke (top row, ninth from the left), who personally outscored the entire New Haven Teachers team in a dual meet.

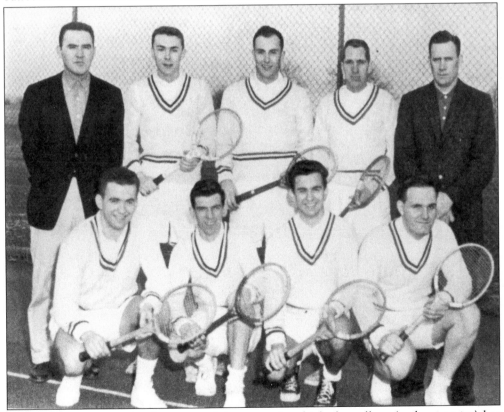

Over the years, tennis has been one of the sports in which the college (and university) has excelled. As an example of this success, depicted is the 1959 men's team. Coached by Bill Detrick, it won the NAIA District 32 championship.

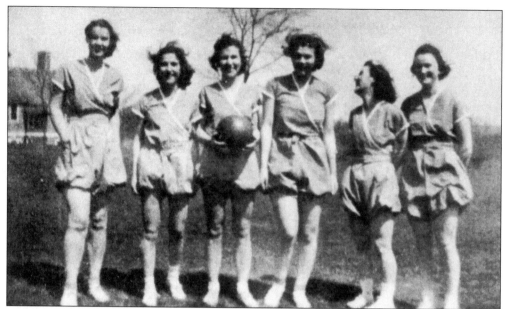

This picture of the 1939 women's basketball team is a reminder of how the game has changed during the past 60 years. There were then six on a team—three forwards and three guards. Players were confined to half the court and could not cross the center line. Only one dribble was permitted. It was quite a lady-like game. No record is reported for the 1939 team.

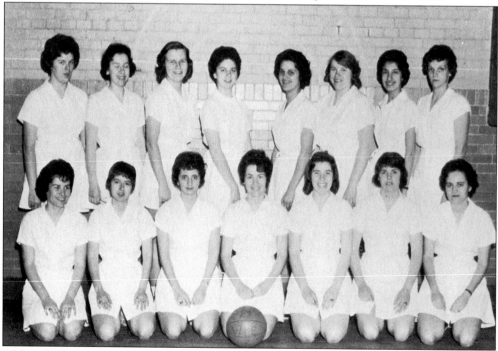

Although there is evidence that basketball was played by women as far back as 1906, the first team to compete on the intercollegiate scene was organized for the 1961-62 season. It played UConn, Southern, Connecticut College, and Bridgeport. There were 15 on the squad: women had returned to five-a-side play.

Long before there was a theatre major, a tradition of quality theatrical performances had existed. M. Agnella Gunn had started the "modern" period in the 1930s, to be followed by such other successful teachers/producers/directors as David Schaal. But the scene shown here is not from a major production. Instead, it is from one of the inter-class play competitions from a time when class identity was very real. This scene from *Hello Out There* was performed with quality by the sophomores in 1956. The juniors won anyway.

In the mid-1960s, the Theatre Department sponsored a real repertory theater group. Led by Thad Torp, who had repertory experience at the University of Iowa, the group did several productions using the same cast. Pictured is the cast of *Dames at Sea*. That summer they also presented *The Crucible* and *Scapin's Tricks*.

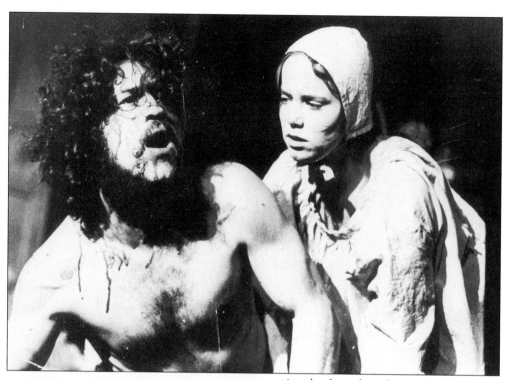

Amidst the political turmoil of the Vietnam years, the Theatre Department mounted an ambitious production of *Marat/Sade* in the fall of 1971. Directed by Lani Beck Johnson, the production featured 66 actors on stage in the administration building College Theatre. Pictured above is Elizabeth Hungerford Hicks comforting asylum "inmate" Andrew J. Maragliano. As a university academic advisor at CCSU today, Elizabeth continues to comfort students.

The College Theatre had been the home to theatre productions since the 1920s, but that changed when the old Stanley School was converted into the fine arts center named Maloney Hall after an alumnus, professional actor, and CCSC professor—James J. Maloney. The first play in the new, flexible, "black box" theatre was *Waiting for Godot*, which opened in spring of 1990. Pictured is cast member Josh Donoghue from the production, looking not so "lucky" on an almost empty stage.

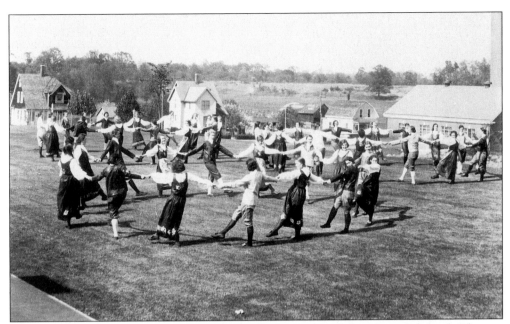

May Day celebrations were major events in the last years of the Normal School. The top photograph shows young women in costume (yes, they were all women) dancing on the lawn above the powerhouse. That year, 1933, Genevieve Zebrowski was crowned May Queen.

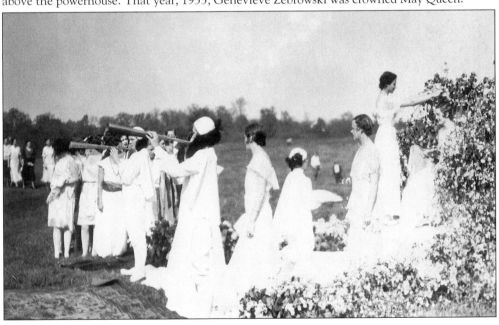

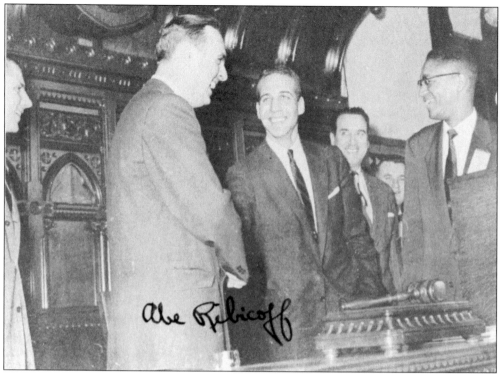

The Connecticut Intercollegiate Student Legislature was a major year-long activity involving all four-year institutions in the state. Bills were prepared, and the college delegations took over the capitol in March for a session. In 1954 David Gifford (above right) was president of the senate and shared the rostrum with Governor Abraham Ribicoff.

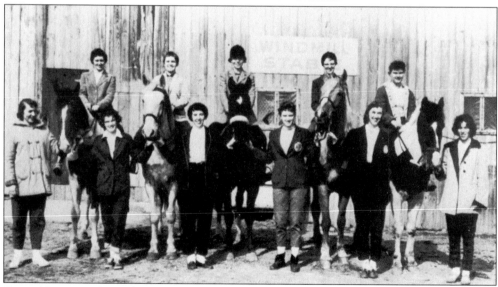

Central has never been known as a "horsey" place. Nevertheless, equestrianism was once a club sport. Sponsored by the Women's Athletic Association, a group of enthusiasts (and horses) are pictured. Perhaps part of the problem for riders was that there were no convenient stables. Windmill Stables was in Farmington.

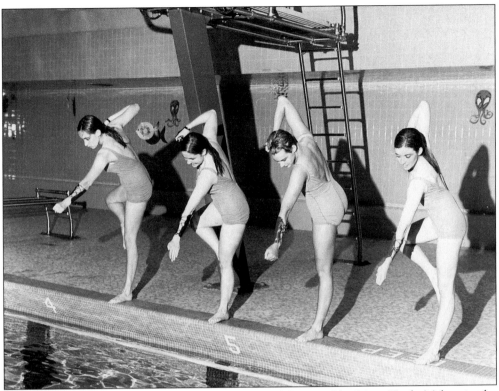

The Blue Dolphins was a synchronized swimming club started by Mary Hoyle Mahan in the mid-1960s and continued by Sandra Macnair until 1973. The Blue Dolphins competed on a club basis with other schools.

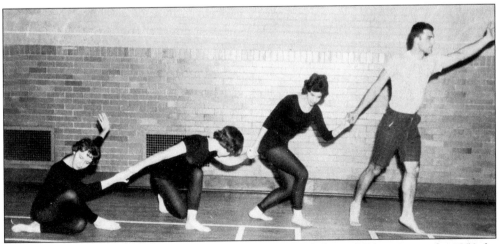

Modern dance classes were originated in the Department of Physical Education in the 1950s by Sunni Bloland, Gloria Bonali, and Dee Perrelli. Catherine Fellows developed the dance program beginning in 1976. Public performances of modern dance were offered by her "CCSC Moving Company" and later "Dancentral." Here an outnumbered male dancer leads the way in a performance in the old gymnasium in Memorial Hall.

In 1968, yes, there was a marching band, but the drum majorettes (traditionally called Twirlerettes) did practice separately on Arute Field.

By the fall of 1946, the football team was back in action. So were the cheerleaders. These four, unidentified, were photographed at the Trenton State game that year.

On November 20, 1973, the first Swingathon Toys for Tots was sponsored by Rho Kappa Sigma fraternity and Theta Sigma Delta sorority. In 1974, toys were also donated by the National Guard, SNET, and WPOP and distributed to children in neighboring communities.

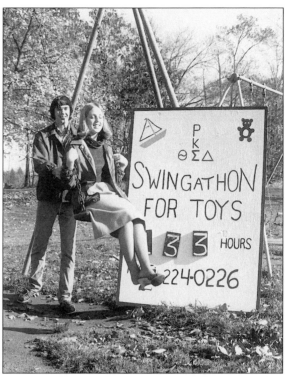

No, this is not from a theatrical production. It is a competitor in the Ugly Man Contest or the Ugliest Man on Campus, as it was variously called. The competition was originated about 1954 by Alpha Phi Omega, the service fraternity, to raise money. Votes cost a penny apiece, and the contestants were faculty members (wearing no makeup). Later it became a real ugly man contest, students taking the challenge literally.

89

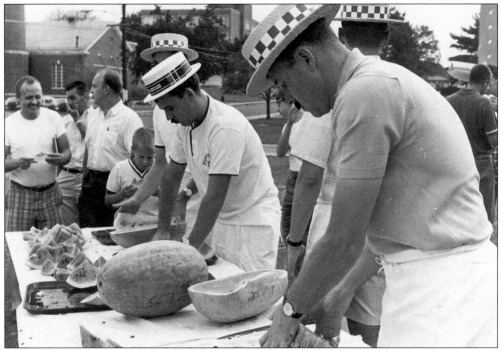

When Dick Judd was director of the student center, a tradition was established that free watermelon would occasionally be served to students and faculty on the lawn outside the Center. Staff, identifiable by their garb, did the honors. The division of Student Affairs carries on the tradition, and the staff is still responsible for cleaning up.

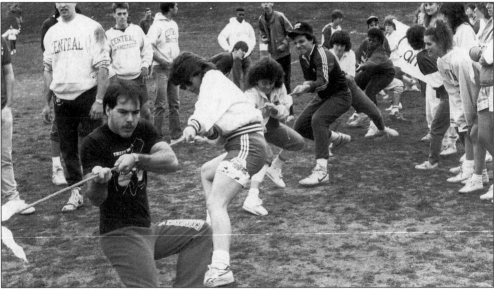

Over the years, various events have been sponsored by the Program Council to enliven the summer. Pictured here is a tug of war with both male and female students giving it their best. Other summer events included ice cream fests, Dixieland Jazz concerts, "Summer Chautauqua," art exhibits, and concerts. All the activities were arranged to provide fun, diversion, and a sense of campus community during the summer class schedule.

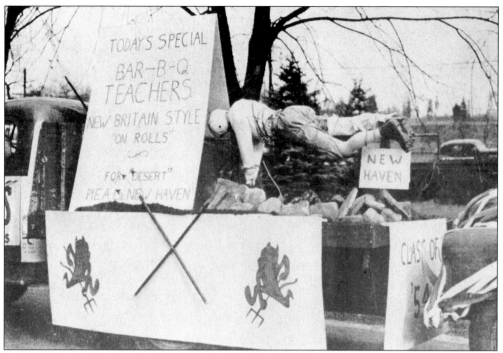

Football and Homecoming have been linked ever since the introduction of intercollegiate football when the men reappeared after 1933, and Homecoming bred class float competitions. This float is notable not only for its bravado but also for its featured use of the Blue Devil. This was 1951. Sadly, New Haven, i.e. Southern, won 28-18.

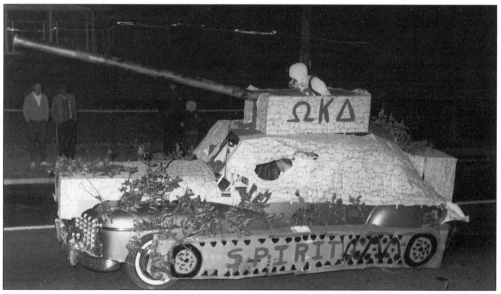

In later years—this is 1962—the sponsorship of floats shifted from classes to organizations such as sororities and fraternities. The fraternity sponsoring this one, popularly known as the OKD's, created a machine that looks like a prototype for "Animal House," which came 15 years later. Interesting, too, because there were those who saw OKD as CCSC's equivalent of "Animal House."

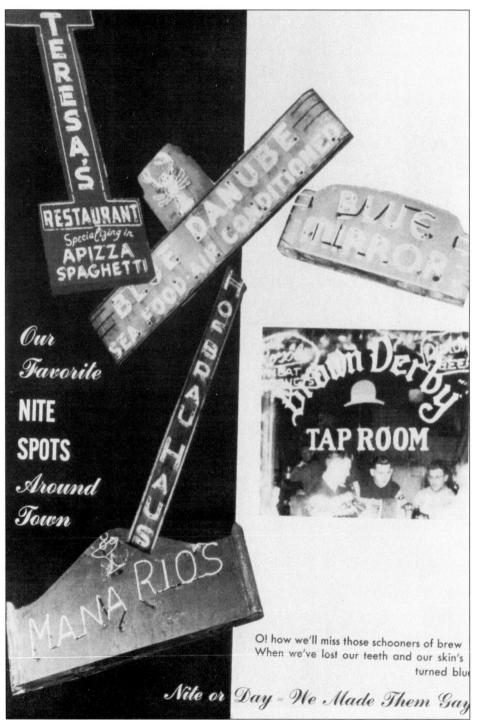

Our
Favorite
NITE
SPOTS
Around
Town

O! how we'll miss those schooners of brew
When we've lost our teeth and our skin's
turned blu[e]

Nite or Day – We Made Them Gay

In the mid-1950s, the *Dial* celebrated some of the more popular spots in the area. Teresa's and the "HB," for instance, were credible eating places, but the students were clearly more impressed by the beer. (N.B.: the brief text demonstrates that usages have changed in the past 50 years.)

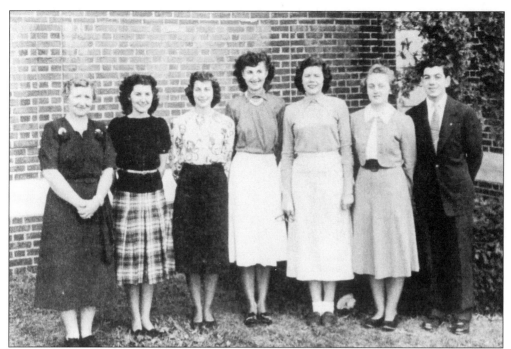

It is 1947, so there was no general shortage of males. Indeed, the Calendar Committee, which is pictured here, had three males, two of whom were absent. What is really represented in this photograph is the changing postwar styles. Hemlines were already heading toward the levels of the "new look."

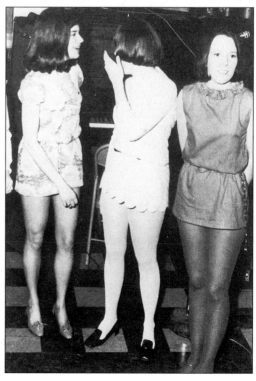

If the "new look" had represented the dominant style of the more conservative 1950s, the late 1960s gave evidence of a dramatic change. This photograph from 1968 is testimony enough of the heights to which the miniskirt has risen. (Well, at least the micro mini was more economical than the worsteds of a short generation before.)

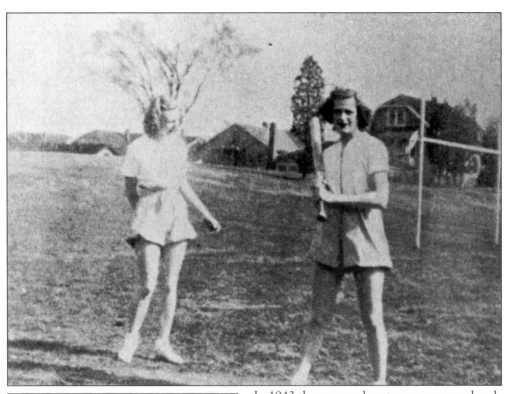

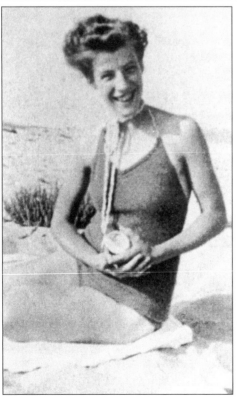

In 1943 there were almost no men around and little evidence of athletics. This photograph was posed: the site is just south of the administration building adjacent to the practice football field (where Willard Hall now stands). There was no softball diamond anywhere nearby.

From the relatively early days of TCC, the *Dial* depicted student recreational activities off campus. Before the war, the administration was quite puritanical, but there is evidence—not just here—that students went to the beaches along the Sound, and there is absolutely no evidence that this represents an academic field trip.

It is the fall of 1938, and Helen Finnegan does not look too happy even though she is identified as "DIV. I." The further significance of this picture is that it clearly shows the tiers of the grassy amphitheater. There are almost no extant photographs taken from the "stage" of the amphitheater.

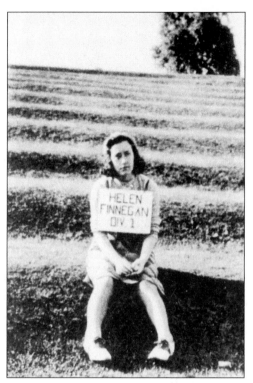

Hazing in its traditional form was to end in the 1960s. It was not "relevant." Nevertheless, as late as 1962 it was still in practice if only in a slightly different form. The key here was menial service rather than mere humiliation. But note that the beanie still reigned.

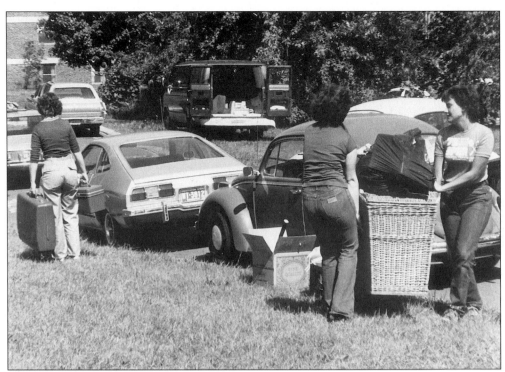

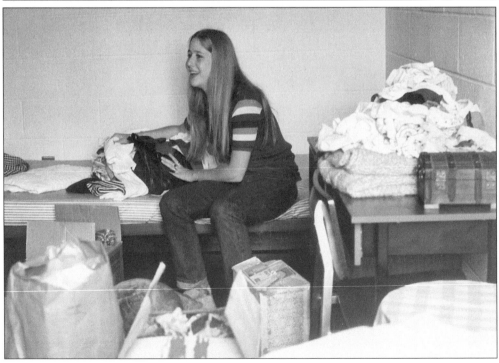

There is a ritual here in three phases. It is all about moving into a dorm. This came to be a hectic process in the 1960s when the number of dormitories and campus residents increased. And everyone was expected to move in within a two-day period.

First there was the problem (top left) of finding a place to park to unload. And then there was the matter of lugging the stuff to rooms in all sorts of containers. (Does anyone believe that wicker hamper came out of the VW Beetle?)

Next came unpacking. The challenge was to find a place for all of it in a room shared with someone you may never have met. But she seems happy in her cinder-block cell—evidence of the low-cost (read cheaply constructed) buildings of that period.

Eventually it could all be sorted out, as the picture above suggests. Except, of course, no one remembers a double room being that neat for any period of time.

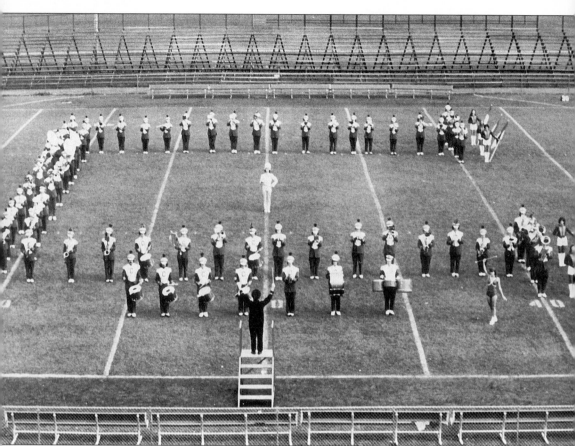

Yes, there was a time when Central had a marching band—uniforms and all. It performed, of course, at football games on Arute Field, hence the practice site. The director was James Shugert, and in 1974, when this photograph was taken, Steve Perry was the drum major.

An annual Christmas event in the late 1960s and early 1970s was the Madrigal to which the college community was invited. There were, of course, a king and queen, jesters, and wenches. On the occasion pictured above, Dick Judd was King, Lani Beck Johnson was Queen, and Jim Fox was a jester. Not pictured: the other jester—Jim Jost.

Although the Blue Devil had been the college mascot as far back as the TCC days, there was no attempt to create a life-size personification until relatively late in the permissive 1960s. He was then created by Searle Lansing-Jones of the Art Department in splendid nudity. Exiled for reasons of taste from Kaiser Hall, the Blue Devil has found a home in one or another part of the Student Center. There are occasional attempts to cover a portion of his anatomy. There is no identified model for the work, according to the artist, but conventional wisdom has it that the figure was based on Michael Cipriano, then a graduate student in art.

Five

PEOPLE YOU
MAY REMEMBER

With each succeeding chapter it has become harder to select the precise images that deliver the proper story. No one is likely to take umbrage at what was or was not included on the Normal School. Subsequently one was dealing with times and places that more and more people remember. If it was hard to do justice to athletic teams or theatre productions or student events, it was harder still to select a finite number of notable colleagues for inclusion. But here are some of the criteria:

The person must have been associated with the institution before 1980.
The person must have exerted considerable influence (for good or ill) on his/her area.
The person is likely, for one reason or another, to be remembered by a substantial number of alumni.
And, most important, there had to be a photograph.

Apologies to anyone who is offended by inclusion or exclusion.

There had been a dean of the college since the late 1940s, but the creation of schools did not come until 1967. It is from that date there was a School of Arts and Sciences. The first dean was Randolph Aurell, a professor of art and an accomplished painter. He served as dean until 1970 when he returned to the Art Department. Randy was highly respected for his even temper and his evenhandedness.

After TCC was established in 1933, men began to enter the college in some numbers. One of the relatively early male students was Justus Beach, from an old New Britain family. He did not simply graduate and go on to teach. He eventually returned in 1960 as a member of the Education Department and remained to become a legend. "J.B.," as he was called, was an innovative teacher whose strategies made him popular in the rebellious 1960s. Conservatives in the administration never understood him.

Between 1953 and 1966, Harold Bingham was one of the most dynamic forces on the campus. He arrived in 1946 to teach American history but became, almost by accident, Dr. Welte's right-hand man at a critical point in the college's history. When UConn submitted the bill that would have transferred all secondary education to Storrs, Bingham was one of a small group designated to defeat the plan. He proved to be a successful lobbyist and became the spearhead in campus growth and development. He was also a leader in the effort to have the teachers colleges become state colleges and served for a time as executive secretary to the Board of Trustees for State Colleges. In the end, however, he fell afoul of four strong campus presidents, including Dr. Welte, who resisted his efforts to create a strong centralized system.

In the 1960s, when enrollments were growing even faster than the additional faculty, a number of strategies were employed to cope with the students. In addition to conventional large classes, there were experiments with instructional television. One of the pioneers was Allen Brown, a member of the Art Department, who taught the freshman introductory course in a TV format. Think about it: art history in black and white on small screens in classrooms all over the campus. Now the large introductory classes at least have large screens and color.

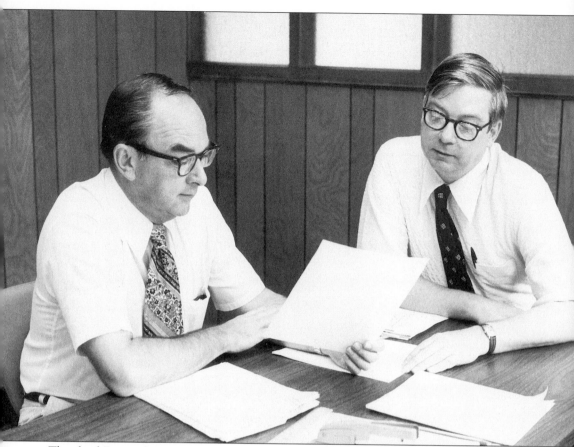

The third Dean of Arts and Sciences was William R. Brown (left), known as "Bob." He left after seven years to be director of the USAID program in the Sudan. He returned subsequently to the Political Science Department and also served in the School of Business before directing CCSU's USAID program in Poland. A no-nonsense administrator, he eliminated the division system in his school, tending to keep the department chairs' "feet to the fire."

Paul Q. Beeching (right) came to Central in 1963 as a member of the English Department. After a successful term as president of the Faculty Senate, he became Associate Dean of Arts and Sciences. For years he was, among other things, the decision-maker concerning student probation or dismissal in the largest of schools, and he was always interested in the maintenance of standards. A Biblical scholar, he has, in retirement, turned to writing and publishing.

John Bulman was one of the faculty members added toward the end of the enrollment bulge created by returning and entering veterans after World War II. He joined the Science Department in 1949, specializing in physics. Although he personified the kind, gentle scholar, he nevertheless rode a motorcycle.

In the Normal School and Teachers College periods, there had been no perceived need for a Philosophy Department. What there was—a course in the philosophy of education—was taught in the Education Department. In the CCSC period, there was increasing pressure for such B.A. programs as philosophy. Leland Creer was hired in 1966 in response to this pressure. Dr. Creer was one of the moving forces that caused a B.A. major to be developed and a Department of Philosophy to be established in the School of Arts and Sciences. Dr. Creer was also one of the founders of the highly successful Honors Program.

With the GI boom over, enrollments remained flat from 1950 to 1955, and new faculty hiring occurred where there was program demand. Secondary history/social science certification was one of these, and William "Bill" Donovan was employed in 1955 as a second person in social science education. For years you were supervised either by Doc Fabyan or Bill Donovan. Dr. Donovan also taught the history of the U.S. South, served as the first supervisor of Seth North Hall, and played a mean game of setback.

William "Bill" Driscoll was one of the young faculty members employed in the late 1960s when enrollments were approaching their heights. He came in 1969 to what was then the Division of Mathematics. He came to teach mathematics education and inherited a portion of George Spooner's mantle for teaching programs in that area in Jamaica. Eventually he became chair of the Department of Mathematical Sciences. (He is sometimes called "Dudley" because of a perceived likeness to Dudley Moore.)

Warren "Doc" Fabyan and his wife, Ida Mae, were both familiar figures on the campus from his arrival in 1949. Moved to the Social Science Department in 1950, he was the leader in social science education until he eventually received support from Bill Donovan. In the meantime, Ida Mae was in charge of the college bookstore in the days when it was operated by the college. Although she lacked faculty status, she was probably better known by students than "Doc."

As late as the end of the Teachers College period there was no program in anthropology. There was only a single introductory course in the sociology minor. With the growth of B.A. programs there developed a sociology major, but anthropology remained a subordinate sub-section. By the end of the 1970s when Kenneth Feder was added to the staff, however, anthropology was emerging as a department in its own right. Dr. Feder was and remains a specialist in the study of Connecticut Native Americans.

Students who applied for admission in the peak enrollment years after 1970 will remember Johnie Floyd, who joined the Admissions staff in 1970. Subsequently he rose to the position of Director of Admissions. However, his service to the university did not end there: he remained until 1998 as special advisor to the president on African-American affairs.

James E. Fox arrived at Central in 1966 as assistant director of the student center. In the early 1970s, when this picture was taken, he was Associate Dean of Student Affairs. Later he served as Associate Dean of Administrative Affairs, Director of Veterans Affairs, and Registrar. Many alumni will recall him as the dispenser of emergency loans and as the appeals officer on satisfactory academic progress.

David Gerstein was one of a number of bright young faculty hired in the early CCSC days. Mr. Gerstein arrived in 1960. Among his specialties was Old Testament literature, a subject he taught in the Honors Program. Indeed, he was one of the original corps of faculty in the Honors Program along with Leland Creer, Paul Beeching, and George Muirhead.

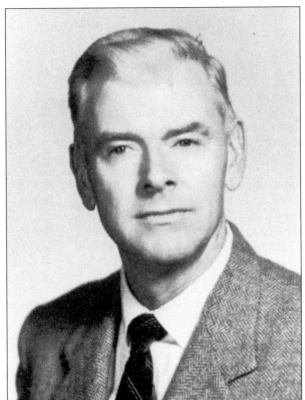

Francis Glasheen was one of the first additions to the English Department in the immediate postwar period. He was, at that time, one of a handful of faculty who held a doctorate, and his just happened to be from Yale. An academic aristocrat who supported his wife's efforts to unravel Joyce's *Ulysses*, he was best remembered by his students for his course in Shakespeare, which he taught largely by reading the plays in stentorian tones.

The man in the center is an unidentified visitor from Latin America, but the other two were members of the School of Education.

Charles Gervase (left) was a TCC alumnus who served in Camp School, the training facility, and eventually became its principal. Returning to the campus, he served as Associate Dean of Education and Professional Studies and subsequently as Dean. He was also "godfather" to the program that links CCSU with Sicily.

On the right is Arturo Iriarte, of Cuban origin, who joined the faculty in 1978 in the Counselor Education program. In addition to teaching, he received a Hispanic Woodrow Wilson Fellowship for faculty interested in administration. This experience resulted in his assuming a leadership role in CCSU's original First Year Experience program. He left to become an administrator elsewhere.

The administrative support staff in the administration building at one time had a social organization called the "Centralites," which had occasional bake sales to raise money for charities and to print its newsletter. This last fact had its irony: the organizer and leader of the Centralites was Rose Hill, who ran the Copy Center but who insisted that her newsletter be printed at the going rate. Seen, left to right in 1970, are Helen Jacubowicz, Peggy (Coppi) Porter, Rose Hill herself, Dottie Vesci, and Professor Gaetano Iannace of the Modern Languages Department.

John Hunter was another addition to the English Department faculty in the booming postwar period. He arrived in 1948. His specialties were two well-feared courses: English grammar and Greek and Roman Classics. These were inescapable in the English major, and Mr. Hunter was more respected than loved. He was nonetheless admired for his natty dress: he often wore a checked vest and more frequently wore a yellow bow tie.

H.B. Jestin spent most of his professional life at Central. He was originally a student at TCC in the late 1930s before being drafted early on. After a career in the military where he rose to the rank of colonel, he returned to TCC and finished his B.S. degree in English. After serving in the Canton school system while earning a doctorate at Yale, he returned to CCSC in 1962 as director of professional education. He was subsequently Dean of the College, the first Academic Vice President, and, while serving in the System Office, named the first Provost of Connecticut State University.

The School of Business grew out of the Department of Business Education, which in turn rested heavily on office practice programs. Bookkeeping was basic, but so were shorthand and typing. Anna Louise Eckersley Johnson joined the faculty in 1952 and was a keen proponent of secretarial skills, obviously including typing. When the new computer technology arrived, she was equally a proponent of "keyboarding."

Louise "Lani" Johnson is a veteran member of the Theatre Department and is currently chair. Her particular expertise is in costumes and makeup, but she also served successfully as a director. In another life, she is a keen student of culture in sub-Saharan Africa with a special interest in Kenya, to which she leads trips in the summer. Additionally, it should be noted that she provided help and advice on this volume; indeed it was originally her idea.

Charles "C.J." Jones, identifiable by his bald head, has been a fixture at Central since 1970. For many years he was the director of the EOP (Educational Opportunity Program), a summer academic program for disadvantaged urban students. He also served as assistant basketball coach and most recently has been the Athletic Director.

One of the first academic appointments to be made after World War II was that of Lothar Kahn. The Department of Modern Languages was almost non-existent, and Dr. Kahn had the advantage of being able to teach both French and German. But more than that he was always the consummate scholar and gentleman. Dr. Welte considered him to be part of his "brains trust."

Depicted in this Commencement 1959 photograph are Dick Judd and George Muirhead. Judd was the president of the senior class, and Muirhead was associate professor of history. They had worked closely in the Connecticut Intercollegiate Student Legislature, Judd as state president and Muirhead as state faculty advisor. Forty years later, Judd was president of CCSU and Muirhead the academic vice president.

Henry "Hank" Majlinger was one of the
first coaches hired after World War II
when the veterans returned. Arriving in
1948, he was one of the young faculty who
lived in the temporary barracks housing.
He will be remembered primarily for his
generations of baseball teams, but he also
coached football—including the
undefeated 1954 team. Individually, he
was an outstanding badminton player.

Frank Marietta is the one member of the
custodial staff who has been immortalized:
Frank Marietta Drive is a campus road
adjacent to Kaiser Hall. This is an
acknowledgment to the services of one
who seemed to keep Kaiser orderly and
functional almost single-handedly. Not
only an outstanding maintenance
worker, Frank was also a welcome father
figure to students.

The approaching completion of the new Burritt Library brought together two of Central's career librarians.

Robert Massmann (left) came to TCC in 1951 as the *de facto* successor to Katherine Strong, who had served since Normal School days and was scarcely equipped to deal with what was becoming a modern library. He worked with the faculty, who sought an unfavorable rating for the facility and was thus in a position to help design the new library of the 1950s. Indeed, his directorship of Library Services lasted long enough for him to oversee the planning and construction of the still newer Burritt Library.

Seen on the right is Francis Gagliardi, who came as Associate Director of Library Services in 1963. He has always been actively involved in special collections and the Rare Book Room. Consequently, his services were invaluable when it came to finding and sorting materials for this volume. Separately, he is an active promoter of CCSU's involvement with the Partners program in Latin America, particularly with Brazil.

In 1959, the year TCC became CCSC and the English Department moved into the top floor of the brand new library, Marian McKenzie joined the English Department, where her specialty was the Romantic poets. Accomplished in the arts, she sang with the college chorus and appeared on stage (as Mrs. Malaprop) in a college theatre production. When the Philosophy Department was created, she held a joint appointment there.

In the latter half of the 1960s, new faculty were being added at the rate of nearly 90 a year. One of the young faculty members who came in 1965 was George Miller. Among other things, he eventually came to be chair of the Mathematics Department, chair of the Mathematics and Computer Science Department, president of the Faculty Senate, and one of George Spooner's heirs to the mathematics education program in Jamaica. But faculty will best remember him as the meticulous chair of the Curriculum Committee, and students as the guy who ruthlessly enforced the Math Placement Exam.

When William "Bill" Moore came to TCC, there were
nine members of the Health and Physical Education
Department—five men and four women. The catalog
listed 52 courses (many of them activities) in addition
to the men's responsibilities for the intercollegiate
athletic program. Young Bill Moore thus started as a
generalist but soon graduated to head coach, e.g.,
basketball, and ended his career at CCSC as a highly
respected director of athletics.

George Muirhead came to TCC as a very young
instructor in 1949, rising eventually to become professor
of history. He served as Curriculum Committee chair for
more than a decade and was the first Director of the
Division of Social Sciences. Turning to administration,
he held three deanships variously and worked with Dr.
Jestin in the vice president's office. Following a semi-
retirement, he returned in the Judd administration as
Vice President for Academic Affairs. (He wrote most of
this book, but not on that typewriter.)

Edward K. "Ted" Owen came to TCC in 1946 with the return of men to the campus, where he served as track coach and Dean of Men. His success in dual meets was legendary, and individual athletes frequently placed well in regional and national meets. As dean, in the event of minor indiscretions, he was likely to recommend solitary contemplation, preferably on the bank of the pond in Stanley Quarter Park. He served for 30 years.

With Dr. Welte here is Theodore Paullin, for many years a tower of strength on behalf of faculty interests. Appointed in 1947, Dr. Paullin rapidly became a faculty leader, serving for a time as Senate president. Largely responsible for the separation of History from the Social Science Department, he built the History Department into an academic powerhouse of 34 members. A deeply committed member of the Society of Friends, he once lost a job in the Midwest for his Quaker position on World War II. He also spent the years 1957–59 in Europe representing Quaker interests. Notwithstanding these principles, he was a shrewd setback player.

Joseph Pikiell came into the Admissions Office at Central in 1958, a very good time to come, indeed. The College was growing; the community colleges were hardly off the ground, and plans were being made for enrollments of 12,000. Applications were flowing in. As Director of Admissions, Mr. Pikiell could be very choosy, and students with high SAT's were being rejected for mediocre class rank. Subsequently, he was promoted to Vice President for Administrative Affairs, which he held until his retirement. He has been immortalized on the campus with "Pikiell Drive," a service road leading to the police station from what used to be Francis Street.

Thomas A. Porter served as the second Dean of Arts and Sciences before leaving for 20 years, most of which were spent in the System Office of CSU. He returned in 1996 to be President Judd's executive assistant. During his career as Dean, he was instrumental in creating the Cooperative Education Program and in the establishment of the Polish Studies program.

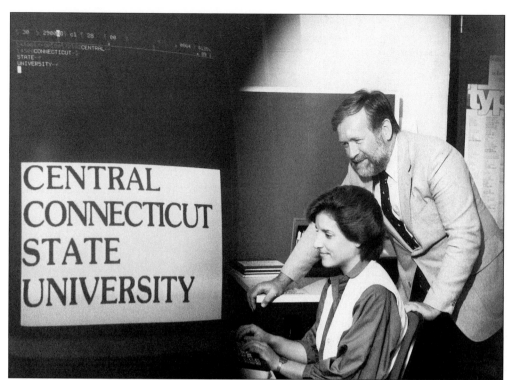

Sanford "Sandy" Rich was an undergraduate student in Industrial Arts who left to earn a graduate degree and then returned in 1959. His specialty under the tutelage of Dr. William Riley was the print shop, and his career developed from the days of handset type. In more recent times, his area in the School of Technology has become graphics production; and, not surprisingly, his print shop does a good deal of the University's print work. That includes Christmas cards, if you are the president.

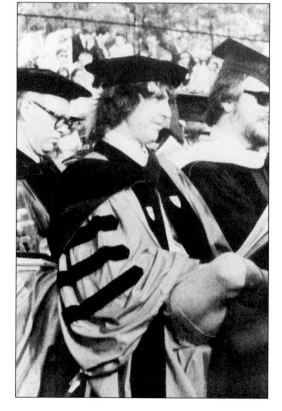

On the left in this picture is the esteemed former chair of the History Department, Murray Katzman; on the right is William "Bill" Hommon, a History Department colleague who was an innovative teacher. Featured, however, is Alfred "Al" Richard, a historian of Latin America who had a notable eccentricity: he wore short pants. Even his tuxedo trousers were short (and his Commencement garb, too). His dog Flower was memorable as well: she used to march in Commencement processions in full academic regalia.

Francis "Frank" Rio was one of the young faculty hired in 1946 during the postwar enrollment growth. He joined a Science Department, which then had fewer than a half dozen members. When William C. Lee was appointed dean of the college, Rio became department chair. In the mid-1960s when the Science Department was broken up on disciplinary lines, Rio became chair of the Physics/Earth Science Department. Later he became the first Director of the Division of Natural Sciences, where he exercised great influence on the space allocations in Copernicus Hall, to the advantage of the sciences. (On the left is Jean Buckwell, an assistant registrar.)

David Ross did his undergraduate work at CCSC and, after a brief absence, joined the Student Affairs staff in 1968. He served as director of the student center, where he led a program of campus beautification, earning him the honorary title of "Dean of Sculpture." As Associate Dean of Student Affairs he oversaw the Student Government Association, among other groups. The year 1998 was good for him: he received the Distinguished Service Award and was promoted to Dean of Students. And for the record, he has walked across England, coast to coast.

Not all the new staff hired just after the war were faculty members intended to serve veterans. M. Isabelle Rupert was one of these. It is true that she was technically an Instructor in English and did some teaching of freshman English, but her primary responsibility was as housemother in Marcus White dormitory. There, from her apartment adjacent to the main entrance, she ruled with an iron hand. She was also interested in drama and for many years was a loyal worker at New Britain Repertory Theatre.

CCSC was still a very conservative place in its early years, dictated, it can be argued, by the ethos of the Teachers College. Thus, Raymond "Ray" Shinn was perceived as something of a maverick when he joined the English Department in 1962. He had long hair. He wore jeans and sneakers to class. He was seen as a hippie before we knew the word, and he was spoken to by the dean about it. But he was exciting to the students and survived. (The dean, for other reasons, did not.)

Edna Mae Saunders Sole was a familiar—and unmistakable—figure around the Normal School, TCC, and CCSC for most of half a century. A graduate of the Class of '25, she received her B.S. and M.S. from Boston University and spent virtually her entire professional life with the college. Most of her career was spent as a supervising teacher at Camp laboratory school in the fifth grade, but she is better remembered as a militant activist for the Connecticut State Employees' Association where she lectured the rank and file on moral imperatives. Always identifiable by her hats, she is seen at her retirement, age 70. She would have worked longer, but retirement at 70 was then the law—and her dean enforced it.

George Spooner joined the faculty of the Department of Mathematics in 1947 as a very young man. Having been a TCC graduate, he was known to Dr. Welte, who hired him and relied on him as a liaison with the student body. This was particularly true in 1953 when student pressure and support were needed to save the secondary education programs from UConn. Dr. Spooner later became a leader in the "new math" movement and was a pioneer in the use of instructional TV to teach the fundamentals of mathematics. He was also instrumental in developing Central's links with Jamaica, where a partnership program still provides training in mathematics for Jamaican teachers.

One of the people heavily responsible for the production of this book is Leroy "Roy" Temple. His chief responsibility has been the conversion of images from a variety of sources into usable pictures for publication. He came into the Media Center in 1972 and was eventually made director. In addition to the traditional media services, Temple also supervises the Faculty Computer Center and supervises the university webmaster.

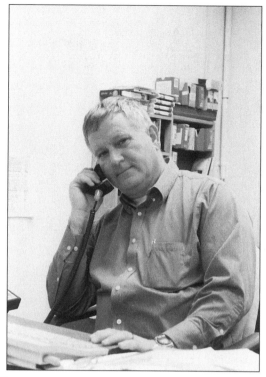

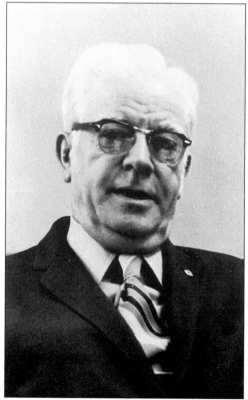

After a career in public school administration, most recently in West Hartford, Edmund Thorne was brought to CCSC in 1964 by Dr. Welte as Director of Professional Education. Three years later when the School of Education and Professional Studies was created, Thorne was named the first dean. At that time the school had three divisions—Education, Business, and Technology, which now are separate schools. Thorne was an accomplished photographer, particularly of wild flowers.

Thaddeus "Thad" Torp joined the small theatre staff in 1963 while it was still a part of the English Department. Subsequently he became a charter member of the Theatre Department when it was formed. Torp, though trained as a costumer, was versatile. He was one of the regular directors, wrote plays in the *commedia dell' arte* style, lectured to monster-sized classes, and translated plays into English (notably Ibsen and Strindberg).

The three individuals pictured above were among the acknowledged leaders of TCC during the mid-century years. Left to right, they are Mariam Underhill, for many years the dean of women who represented the tradition of gentility expected of young ladies; Mildred Barrows, the long-serving principal of Stanley School who joined the training school faculty in 1916 and who represented the insistence on quality in teacher training; and Dr. Welte, the president. The photograph was taken in 1966 at the retirement of Miss Barrows.

Susan Vial is one of the few faculty who began as a graduate assistant and worked her way up to full professor, going through all the ranks. Working originally within the Art Department, she almost single-handedly developed Central's Design program, which has achieved its own department. Central Design, a producing workshop of her outstanding seniors, provides many of the University's promotional materials.

Etzel Willhoit was one of the very few faculty to be hired during the war. He came in 1944 to take over the instrumental music program. There was no music major yet, but there were performing groups. Dr. Willhoit's chief interest was in a symphony orchestra, and he was the founding conductor of the New Britain Symphony. He was reputed to have hired faculty because he needed their expertise in the city orchestra. He was also the one who influenced the design of Welte Auditorium so that it was first and foremost a concert hall.

CENTRAL
CONNECTICUT STATE UNIVERSITY

1615 Stanley Street P.O. Box 4010 New Britain, CT 06050 - 4010 www.ccsu.edu

Office of the President Tel: (860)832-3000 Fax: (860)832-3033

March 1, 1999

To Friends of Central:

George Muirhead never said this, but he very well could have: *History should not be construed to be a cage to hold the opinion of an idea, place, or occurrence, but rather a scaffold upon which to build.* The panoply of photographs collected and researched by Dr. Muirhead represents the rich and abundant years of Central Connecticut State University, depicting remembrances of its leaders, students, and the campus. The inspiration of our past 150 years leads us into tomorrow, and the photographic history in these pages portrays how far a tiny institution chartered to train teachers for the "common schools of Connecticut" has traversed to reach its sesquicentennial in 1999. I extend the very grateful thanks of our faculty, students and alumni to George and those who assisted him for this significant contribution to Central Connecticut State University's 150th!

Richard L. Judd '59
11th President

128